STAFFORDSHIRE AIRFIELDS

THROUGH TIME

Alec Brew

AMBERLEY

First published 2019

Amberley Publishing
The Hill, Stroud
Gloucestershire, GL5 4EP

www.amberley-books.com

Copyright © Alec Brew, 2019

The right of Alec Brew to be identified as
the Author of this work has been asserted in
accordance with the Copyrights, Designs and
Patents Act 1988.

ISBN 978 1 4456 8720 9 (print)
ISBN 978 1 4456 8721 6 (ebook)

British Library Cataloguing in Publication Data.
A catalogue record for this book is available from
the British Library.

Typeset in 10pt on 13pt Celeste.
Origination by Amberley Publishing.
Printed in the UK.

Introduction

Staffordshire is one of the few counties to be able to boast that it has had airfields for more than a century. They were created in three distinct phases beginning in 1910, when first Dunstall Park Racecourse, Wolverhampton, and then Bass's Meadow, Burton-on-Trent, agreed to allow flying. The first ever All-British Flying Meeting, and only the third ever, took place at Dunstall Park in June of that year, and Bass's Meadow hosted another in October. During the First World War an airfield was established at Fern Fields, Perton, Wolverhampton, as part of the defence against Zeppelin raids, and a strip was used at Halford's Lane, Smethwick, to fly Handley Page bombers built by the Birmingham Carriage Company. After the war only the Perton airfield and Bass's Meadow remained in use for flying, by the odd flying circus or joy-ride operator and the occasional light plane, but they remained little more than large grass fields with little or no infrastructure.

During the early 1930s civic pride caused three municipal airports to be built in Walsall (Aldridge), Stoke (Meir Heath) and Wolverhampton (Pendeford). In each case they were all-grass with a single hangar and a small clubhouse/terminal for a local flying club. Wolverhampton managed to attract Boulton Paul Aircraft to build its new factory adjacent to the new airport and gave the company free flying rights for 100 years.

The Second World War caused a massive airfield-building programme across the county. Both Stoke and Wolverhampton were taken over for the use of Elementary Flying Training Schools, and many new buildings and hangars were erected. A shadow factory to be operated by Rootes Bros was built alongside Meir to build Blenheims and then Beaufighters. Walsall Airport at Aldridge was only used by the newly formed Air Training Corps gliding units and by the aircraft serviced by the Helliwells, with a factory built alongside.

Huge new airfields were built to house bomber Operational Training Units at Hixon and Lichfield, the latter also hosting a Maintenance Unit to store and prepare aircraft for the RAF, making it the largest airfield in Staffordshire. These two units also had satellite airfields built at Seighford and Tatenhill. Further large training airfields were built at Wheaton Aston and Halfpenny Green, operating twin-engined aircraft for crew training. A fighter airfield was built alongside the First World War airfield at Perton, but in the event this was used as a satellite for the units at Wheaton Aston and Shawbury in Shropshire.

To provide extra room for the Elementary Flying Training Schools, grass satellite airfields were built at Penkridge, Abbots Bromley and Battlestead Hill, near Burton. Finally, Relief Landing Grounds for the

storage of aircraft were created in the grounds of stately homes at Teddesley Park and Hoar Cross. Arguably the most important RAF base in the county was at Stafford, but this was just a vast storage facility without an airfield, though light aircraft could, and did, land nearby.

Thus, by the end of the Second World War there were fifteen active airfields in Staffordshire. The end of hostilities brought the closure of most of them. The three municipal airfields returned to civilian use, and RAF Lichfield continued to operate well into the 1950s. RAF Halfpenny Green was reactivated for three years, in 1950, with the outbreak of the Korean War, and two years later Boulton Paul Aircraft, still operating at Pendeford, bought and refurbished Seighford, west of Stafford, as its Flight Test Centre for the Canberra bombers it was modifying. RAF Lichfield closed in 1957, so the helicopter landing pad at RAF Stafford sees the only RAF take-offs and landings in the county these days.

Stoke and Walsall airports saw little post-war flying and eventually closed in 1970 and 1956 respectively. Wolverhampton lasted a little longer, but with the end of Boulton Paul's production of aircraft, it too closed in 1971, after the company waived its flying rights. By then Halfpenny Green had been reopened once more, in 1961, for civilian flying, and that replaced Pendeford as Wolverhampton's de facto airport.

Bass Brewery revived Tatenhill to house its corporate aircraft and that had developed as the civil airfield for the north of Staffordshire, and microlight airfields have been created at Roddidge near Lichfield, on part of the former RAF Penkridge, renamed Otherton, and part of Seighford, closed by Boulton Paul in 1965, is used by the Staffordshire Gliding Club. The Needwood Forest Gliding Club operated near the wartime strip at Hoar Cross for some time, but is now closed.

At the time of writing there are just two full airfields in Staffordshire, at Halfpenny Green and Tatenhill, plus the microlight airfields at Otherton and Roddidge and the glider airfield at Seighford. In addition, a busy farm strip at Yeatsall Farm operates just over the road from the former RAF Abbots Bromley.

Apart from these, what has become of Staffordshire's airfields? Several – Pendeford, Stoke, Perton and Battlestead Hill – are housing estates, while the buildings of Lichfield, Seighford and Hixon have been incorporated into large industrial estates. The First World War airfield at Perton is a golf course, Dunstall Park continues as a horse-racing venue, though reduced in size, and Wheaton Aston, Teddesley Park, Hoar Cross and Abbots Bromley have returned to agriculture. Apart from the airfields still in use, Walsall Airport at Aldridge is still much as it was, but is used as community open space, as is Bass's Meadow at Burton.

Abbots Bromley

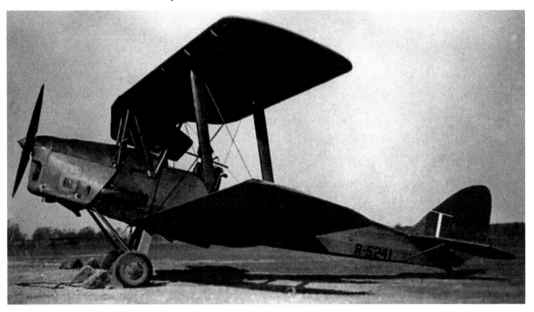

Wartime Tiger Moth Trainer
Above: A Tiger Moth, apparently of No. 16 Elementary Flying Training School, which used the grass airfield just to the west of Abbots Bromley village as a Relief Landing Ground for its base at Burnaston. After opening in 1940 Abbots Bromley was used first by the Miles Magisters No. 5 EFTS at Meir, and to begin with No. 16 EFTS also used Magisters before switching to the Tiger Moth.

Below: An altogether larger biplane, the Antonov AN-2 *Rare Bear* registered in Latvia but based at nearby Tatenhill for some years, is seen on the strip at Yeatsall Farm, Abbots Bromley, just over the road from the wartime airfield.

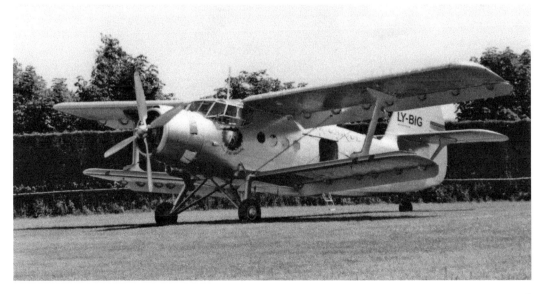

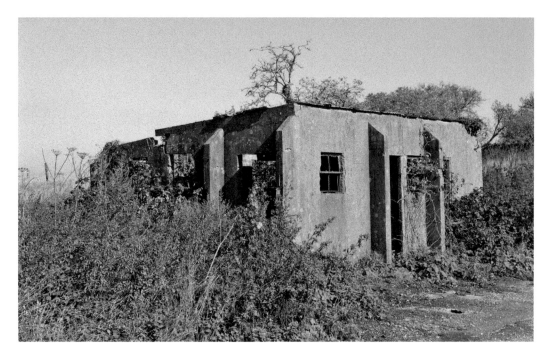

RAF Abbots Bromley Guardhouse
Still surviving by the road just to the west of the village is the wartime guardhouse, now one of the few reminders that there ever was an RAF airfield here, as all the hangars have gone. On the new strip a wartime Piper Cub stands outside one of the former farm buildings, which houses the resident aircraft.

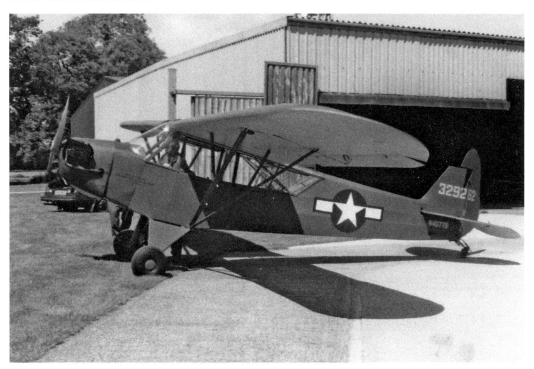

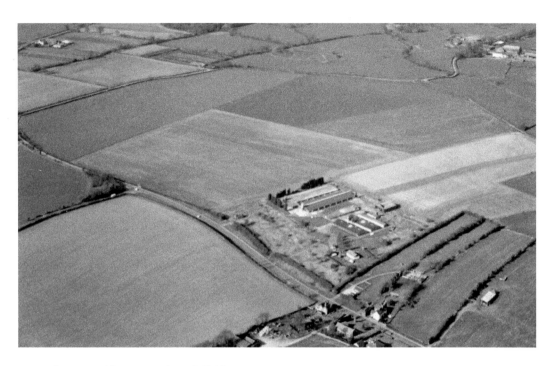

The Two Abbots Bromley Airfields

A post-war photograph of wartime RAF Abbots Bromley to the north of the Uttoxeter road with a few wartime buildings within the chicken farm in the centre, including a Robin hangar. There were just an officer and seventy-four men stationed there. The Robin hangar has now been demolished. The current farm strip is in the large field to the left of the road, with the runway nearer to Blithfield Reservoir. At a fly-in in 2008 almost the whole length of this farm strip was used for parking aircraft, including the Bulldog in the foreground. For the day Yeatsall Farm was the busiest airfield in Staffordshire.

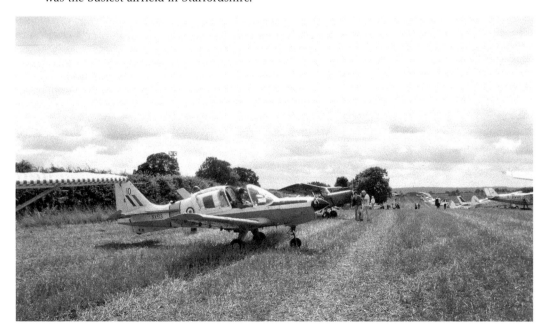

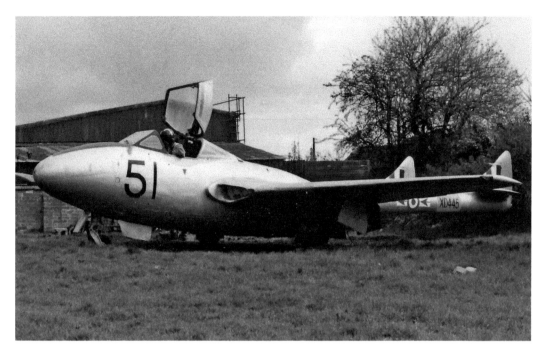

A Jet comes to Abbots Bromley

For a few years the Staffordshire Aircraft Restoration Team based Vampire T.11 XD445 at Yeatsall Farm strip. It became a highly visible turning point for local light aircraft. The fuselage is now on display at Wolverhampton's Tettenhall Transport Heritage Centre. Two complimentary aircraft based there for a while were the Aeronca Champion G-BPGK, built in 1956 though in wartime markings, and its close relative, the Champion Tri-Traveller G-ARAS.

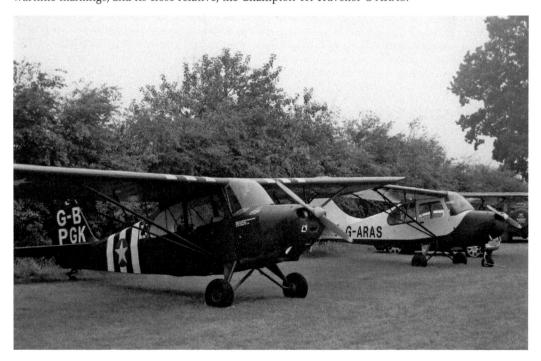

Bass's Meadow, Burton-on-Trent

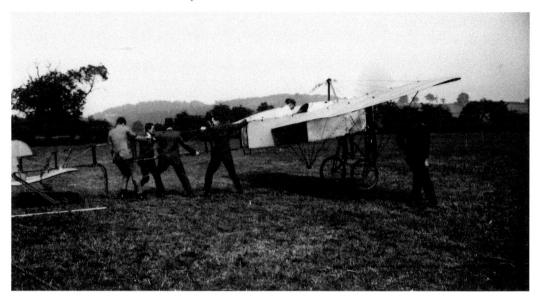

Sidney Pickles' Bleriot Monoplane
Helpers hold back Sidney Pickles' Bleriot as he runs up the engine. He won the height competition in the 1913 Flying Meeting, with 6,100 ft, and took up a number of passengers during the week. Pickles was an Australian who had come to Britain to learn to fly the previous year. In the background are the hills towards Repton. Nowadays a cricket pitch lies in the approximate area.

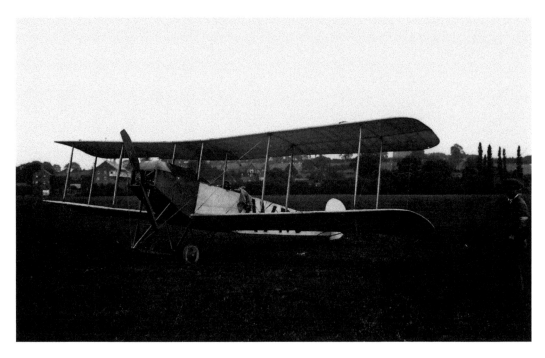

Fred Raynham's Avro Biplane

One of three aircraft that flew at the 1913 August Bank Holiday Flying Meeting was Fred Raynham's 50 hp Avro, the precursor to the famous Avro 504. Raynham became one of the most famous test pilots of his day. As well as the modern-day cricket pitch and trees, the electricity pylons would be an obstacle to flying today.

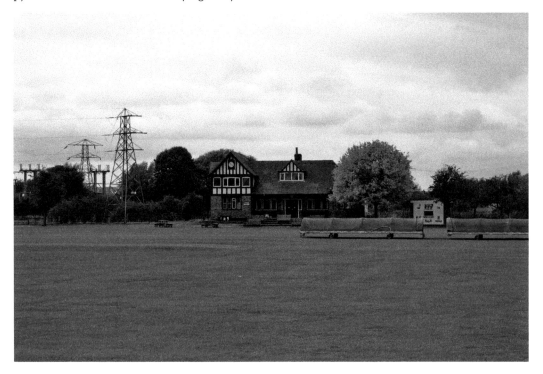

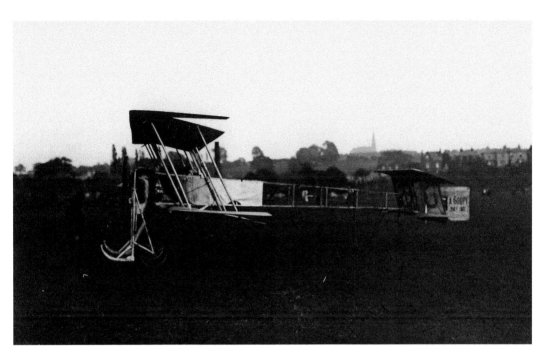

Emile Ladougne's Goupy Biplane

One of the more unusual aircraft at the October 1910 meeting at Bass's Meadow was the Goupy Biplane, which was something of a trendsetter as it had forward staggered wings for better downward and forward visibility. In the background is St Mark's Church at Winshill, seen from the other side in the modern picture, in better weather.

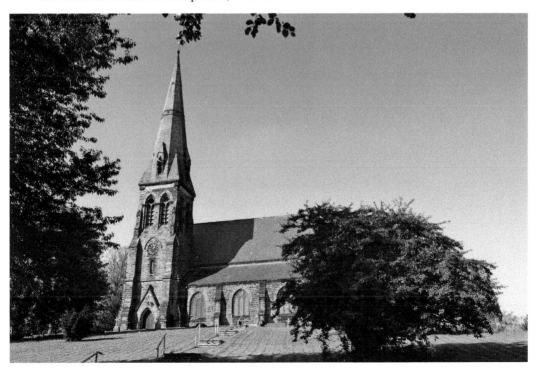

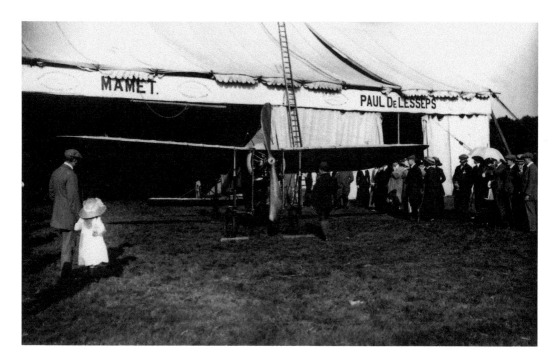

Julien Mamet's Bleriot Monoplane

Both Mamet and Paul de Lesseps (son of the builder of the Suez Canal) brought Bleriots to the 1910 meeting, and they were housed in canvas hangars. Mamet made one flight to Lichfield and back, but when de Lesseps tried to emulate him he became lost and had to land on a farm, where the farmer housed the Bleriot for free, but charged locals a shilling a time to see it! When de Lesseps continued the next day he became lost again and landed at Nottingham. A more permanent building near the spot today is the cricket pavilion of the Washlands Sports Club.

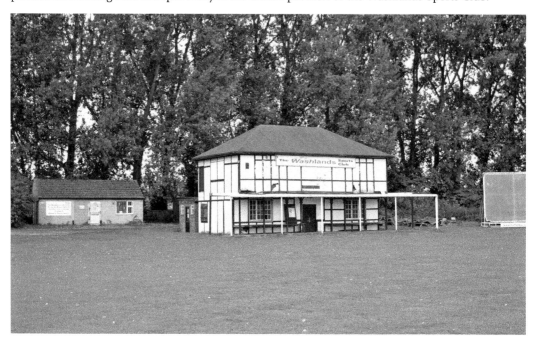

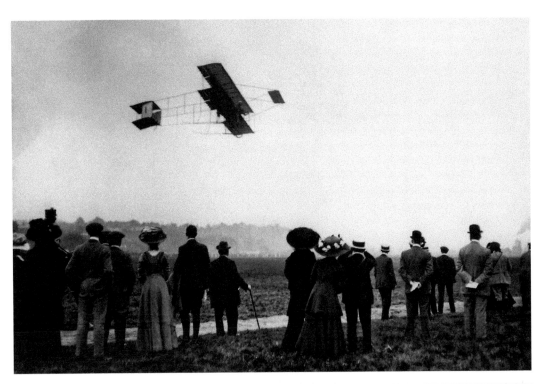

Edouard Beaud's Farman Biplane
There were three Farman biplanes at the 1910 meeting, including this one flown by Frenchman Edouard Beaud (born in Algeria). Beaud had only achieved his French Aviator's Certificate No. 150 on 19 July of that year. Up to 29,000 people attended on the best day of the 1910 meeting, which was only the second flying meeting in Staffordshire, after the one in Wolverhampton in June. People came from all over the West Midlands at a time when few had ever seen an aircraft. An important feature of both flying meetings was a signalling system on the top of Burton's famous Waterloo Tower, with flags displayed to show when flying was taking place. It is still used for signalling today, but via mobile phone aerials.

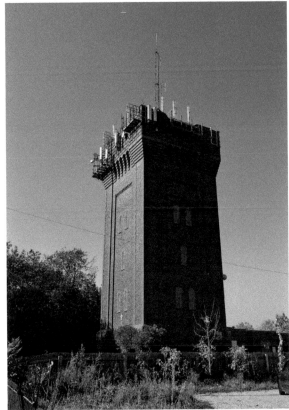

13

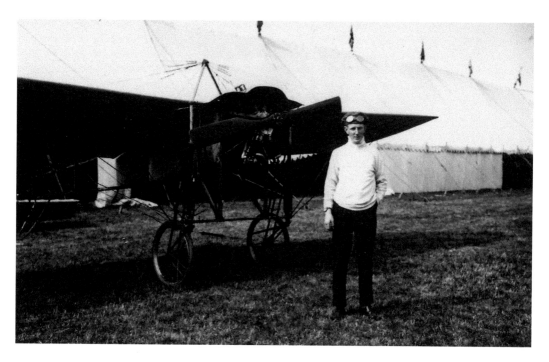

Sidney Pickles and His Bleriot

Pickles was to become a familiar sight around Britain before the war, and he became a Flight Lieutenant in the Royal Naval Air Service during the First World War, and later became Chief Test Pilot at Short Bros, Blackburn Aircraft and Fairey Aviation. He famously flew through Tower Bridge in a Fairey Seaplane in 1919. He returned to his own country and pioneered airmail flights, before moving to British Columbia in 1928, where he lived until his death in 1975. Near the spot today is the home of Burton Model Engineering Society and their rail tracks.

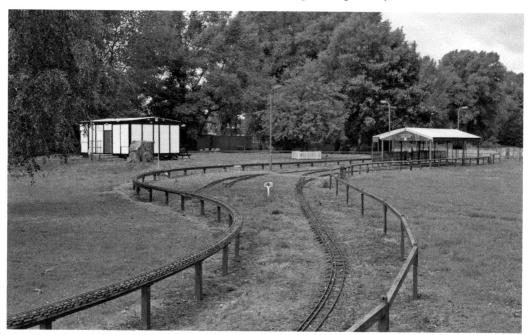

Dunstall Park

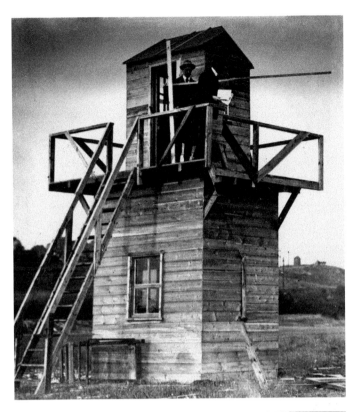

The First Control Tower in Staffordshire
For the June 1910 All-British Flying Meeting in the centre of Dunstall Park Racecourse, this wooden 'control tower' was erected, from which the activities of the airmen could be monitored and flag signals flown. In the same spot today the rather more impressive racecourse grandstand has been in place since the course was redeveloped in 1993, going from a triangular traditional grass course to a smaller oval all-weather one, with the grandstand sited in the centre of the old layout.

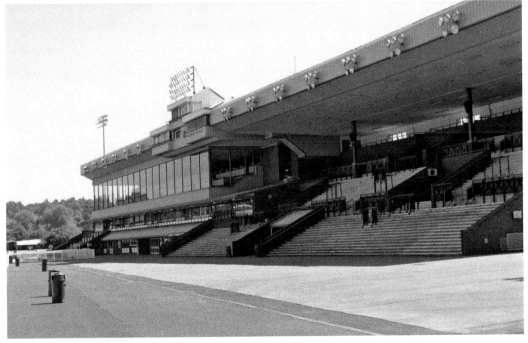

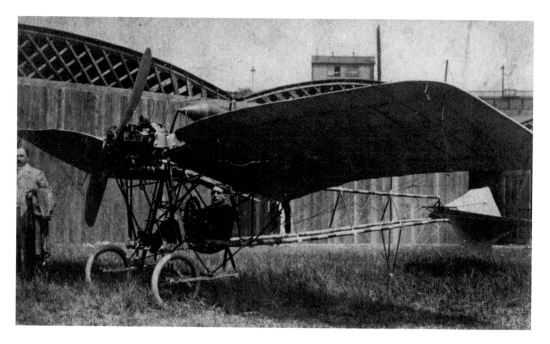

Wolverhampton's First Aircraft

Edgar Hartill, the Wolverhampton plumber, sits at the controls of the monoplane he had been commissioned to build by a Birmingham doctor, Dr Hands, who stands at the wing tip. Hartill had clearly copied one of the well-known successful aircraft of the day, the Santos-Dumont Demoiselle, of which nineteen were built. Unlike the Demoiselle, the Hartill Monoplane failed to leave the ground. On around the same spot, this racecourse accommodation block has now been built.

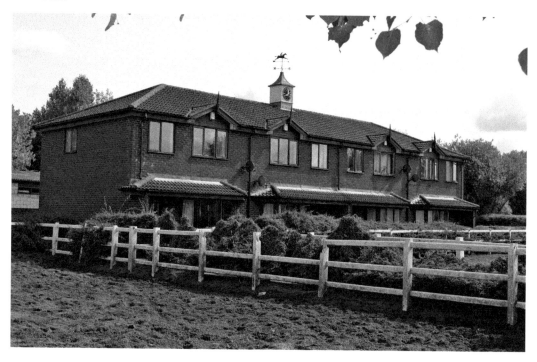

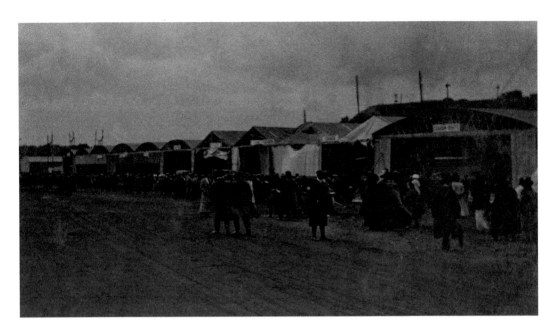

The First Aircraft Hangars in Staffordshire
The Midland Aero Club, who sponsored the 1910 Flying Meeting, built a row of six hangars along the canal side of the racecourse, and some of the visiting aviators built more, including the most famous British aviator of the day, Claude Grahame White, who housed his Farman biplane in the nearest and Cecil Grace his Short S27 biplane next door. Nowadays rows of stables perform the same purpose for rather different steeds.

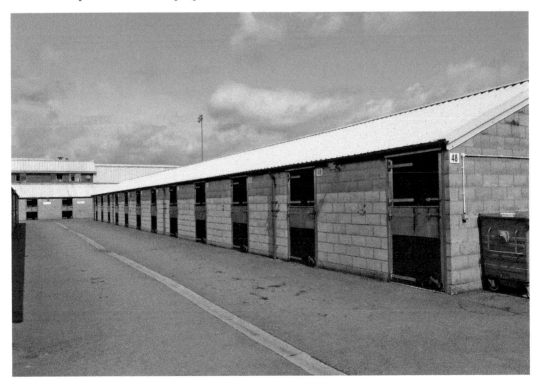

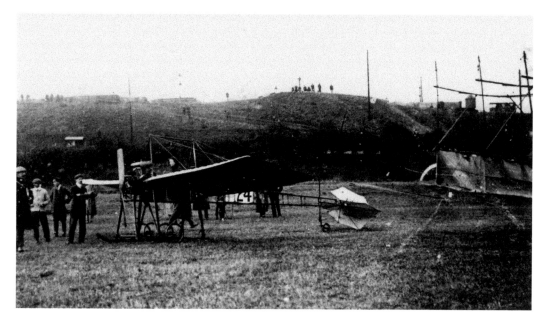

Alan Boyle's Howard Wright Avis Monoplane
Railway workers in Oxley Sidings in the background had a grandstand view of the flying, some of them on the steep entry road. The Avis Monoplane was designed by a Tipton man, Howard Theophilus Wright, who had already built several aircraft and a helicopter. Alan Boyle had only just learned to fly on it, down at Brooklands on 10 June, and he managed just 7 minutes 53 seconds of flight during the Meeting. Nowadays a winning horse is cooled down after a race not far from the same spot.

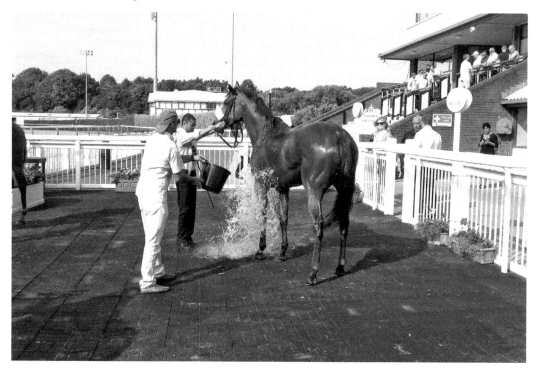

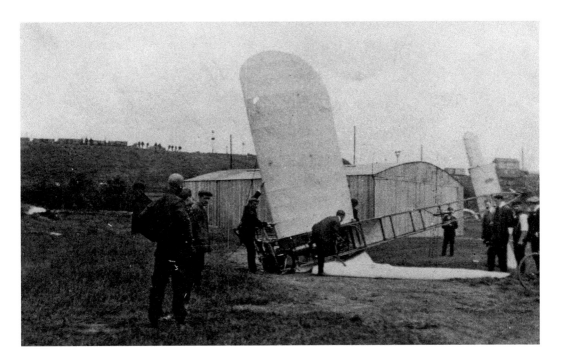

Captain George Dawes; Wrecked Humber Monoplane

Boer War veteran Captain George William Patrick Dawes attempted to gain his Aviator's Certificate so he could take part in the meeting but stalled and crashed his Humber-built Bleriot on 17 June. He stands uninjured in the foreground. The aircraft was repaired and he obtained his Aviator's Certificate No. 17 after the Meeting – the first man to get his pilot's licence in Staffordshire. He was to command the Royal Flying Corps in the Balkans in the First World War, and was a Wing Commander in the RAF in the Second World War. The all-weather racecourse runs through the same spot today.

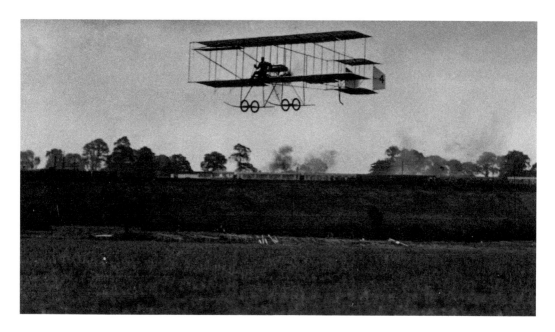

Claude Grahame White's Farman Biplane

Graham White had shot to fame just before the 1910 Meeting by taking part in an air race from London to Manchester with Frenchman Loius Paulhan, and making the first ever night take-off in a vain attempt to catch his rival. He is seen here flying with Oxley Sidings in the background. He was to win the £1,000 prize for the greatest aggregate flying time of 1 hour 23 minutes 20 seconds. Today he would be about to collide with the upper storey of the Holiday Inn, to the right of the grandstand. He went on to create his own aircraft company and to found Hendon Airfield.

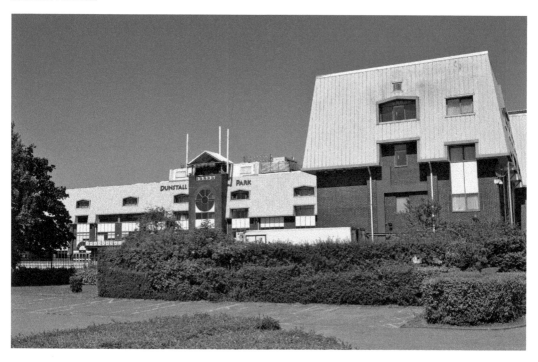

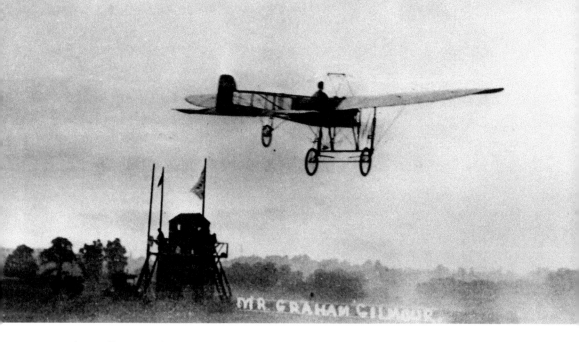

Graham Gilmour's Bleriot Monoplane

Days before arriving at the Meeting, Graham Gilmour had been the first man to fly over the River Clyde, with 35,000 people watching. He is seen passing the 'control tower' in the centre of the course, but only managed an aggregate 7 minutes 5 seconds. Exactly 100 years later, to commemorate the 1910 Meeting Bob Arnold of the Staffordshire Aircraft Restoration Team flew his Whittaker Microlight at Dunstall Park, in the prop wash of the pioneers.

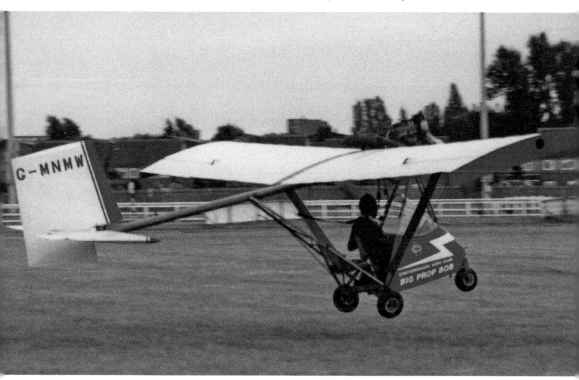

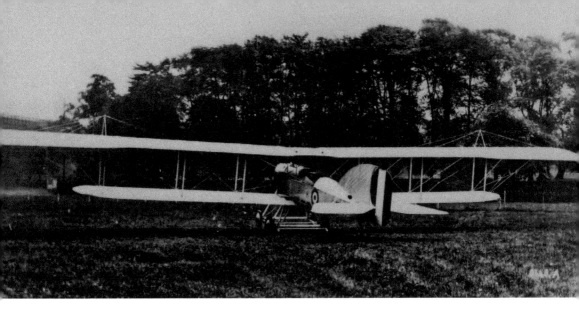

Sunbeam-built Short Bomber
During the First World War Dunstall Park was used to test aircraft built by the Sunbeam Motor Car Co. This is the first of fifteen 240 hp Sunbeam Ghurkha-powered Short Bombers that they built, being tested with four underwing bombs. Dunstall Viaduct is in the background. Nowadays the bomber would be on the racecourse car park, and the viaduct has electrification gantries on top.

Halfpenny Green

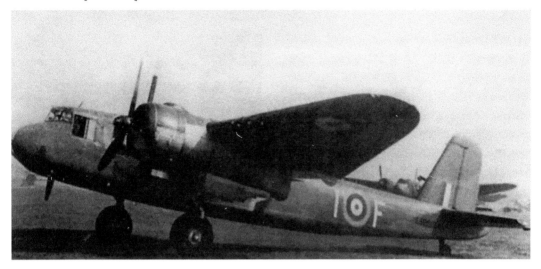

Blackburn Botha

Halfpenny Green opened in April 1941 as RAF Bobbington, the home of No. 3 Air Observer and Navigator School, which was equipped with Blackburn Bothas that had failed as maritime bombers. Underpowered, they were soon replaced by Avro Ansons in this trainer role. In 2014 another RAF twin-engined aircraft arrived for a Wings & Wheels fly-in, the de Havilland Dove from Coventry. A de Havilland Chipmunk with a matching colour scheme is in the background.

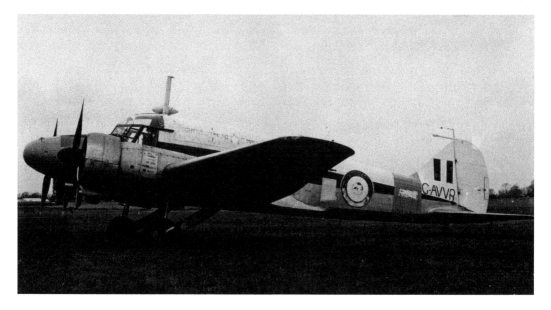

Avro Anson: The Type Most Associated with Halfpenny Green

Following replacement of the Bothas there were two name changes, when the airfield became RAF Halfpenny Green, as Bobbington was apparently being mistaken for RAF Bovingdon, with No. 3 AONS becoming No. 3 (Observers) Advanced Flying Unit in 1942. The airfield closed at the end of the war but was reopened in 1950 for three years, because of the Korean War. Ansons, including this one, returned in the late 1960s when Tipper Air Transport bought several retired examples and parked them at Halfpenny Green while they looked fruitlessly for buyers. A 2011 fly-in brought ex-RAF aircraft back, including the Chipmunk and Bulldog seen here.

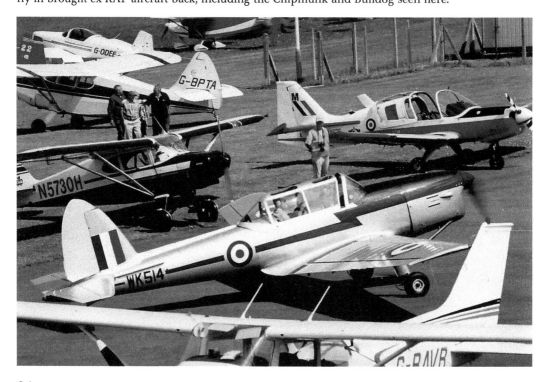

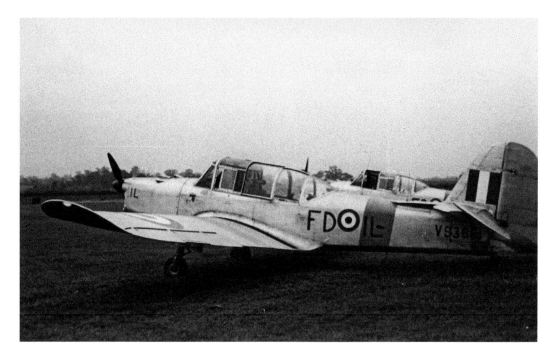

Percival Prentices

In 1950 No. 2 Air Signallers School operated Ansons and ten Percival Prentices. The airfield had been reopened because of the Korean War, but closed again in 1953. In 2012 a Percival Prentice returned to Halfpenny Green for a Wings & Wheels fly-in, when VR259 of the Classic Air Force came from Coventry for the day, and helped to illustrate how little the airfield had changed over the previous sixty years.

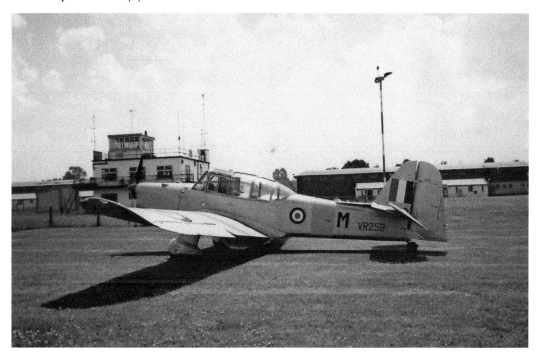

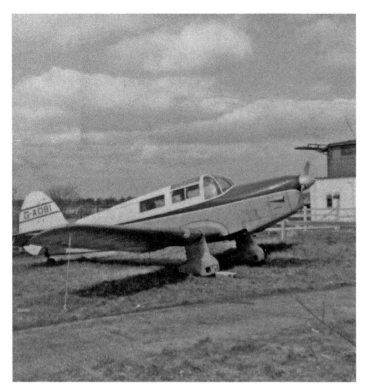

The Air Scouts' Proctor No. 20 Stourbridge Air Scouts were founded at Halfpenny Green in 1964, and have occupied one or the other of the wartime buildings ever since. For many years they were custodian of this Percival Proctor, G-AOBI, which had been a long-time resident of Wolverhampton Airport at Pendeford until retirement. For the fiftieth anniversary celebrations of the Air Scouts, the Classic Air Force kindly flew in their Proctor, G-AKIU, from Coventry, as a reminder of G-AOBI.

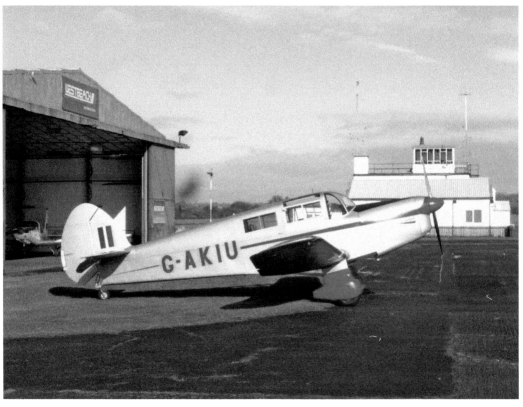

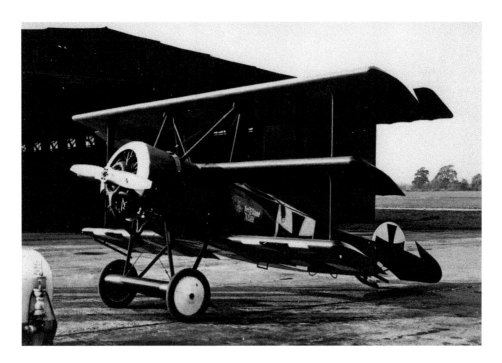

Fokker Triplane

A very unusual visitor in the 1970s was this Fokker Triplane replica, which had been built for the film *The Blue Max*. It's standing on the apron between the surviving three Bellman hangars of the seven which were originally built. Just off the same apron in 2015 is an aircraft which looks older than it really is, just like the Fokker replica. It is a Microlight Aviation Tiger Cub microlight G-MMFS named *Black Adder* in the mobile exhibit of the Tettenhall Transport Heritage Centre, where it is normally based. Its Lewis gun is a wooden replica.

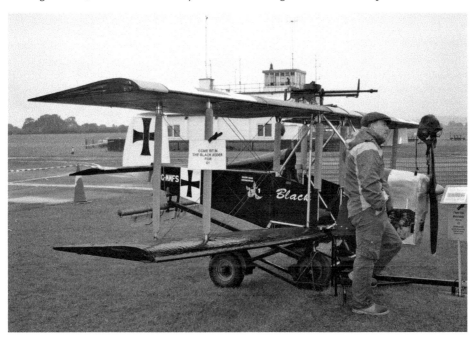

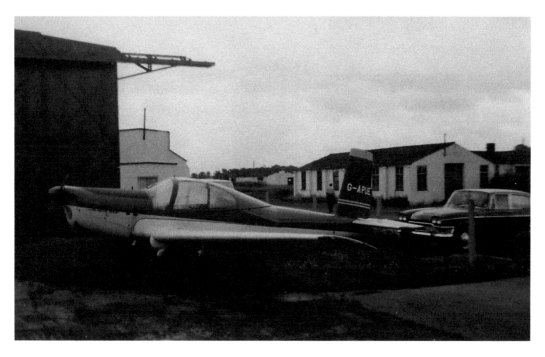

Czech Meta-Sokol

In the 1960s this Czech Meta-Sokol light aircraft, G-APUE, was a resident of the airfield for some time. All the buildings in the background are still in use for different businesses. On the same piece of grass in 2015 is a Maule displayed appropriately with an American pick-up, both aircraft being staples of the American rancher.

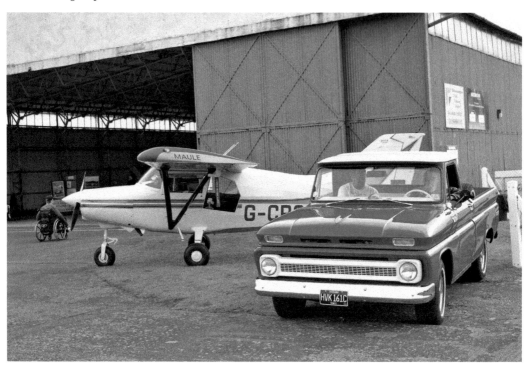

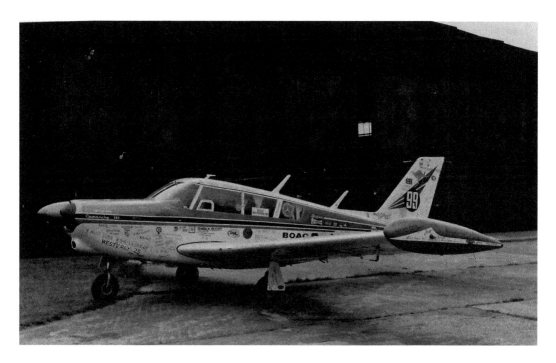

Sheila Scott's Comanche

At a 1960s fly-in, the actress Sheila Scott arrived in her Piper Comanche, G-ATOY *Myth Too*, in which she had flown around the world twice and set ninety aviation records. It is covered with signatures from people she met on the round-the-world flights. In the same aircraft she became the first person to fly over the North Pole in a single-engined aircraft. Another Piper arrived for a 2015 fly-in, Colt G-ARON, which had been based at Wolverhampton Airport, Pendeford, when it first came to the UK with Don Everall Aviation.

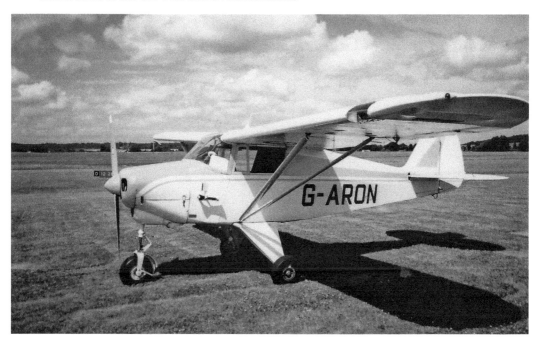

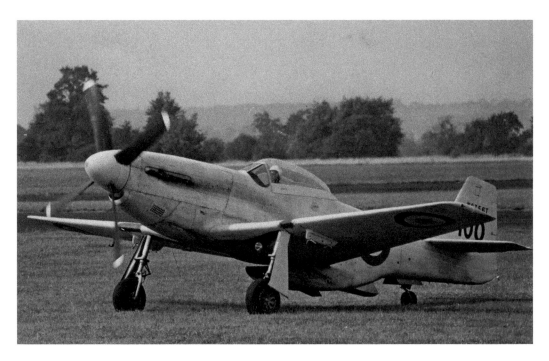

Mustangs at Halfpenny Green
For a time in the 1960s and '70s the Goodyear Trophy Air Race was held at Halfpenny Green, and one entrant was Peter Masefield's North American Mustang, when Mustangs were very rare beasts indeed in Europe. Years later, in 2017, Mustang G-SHWN came to be based at the Green.

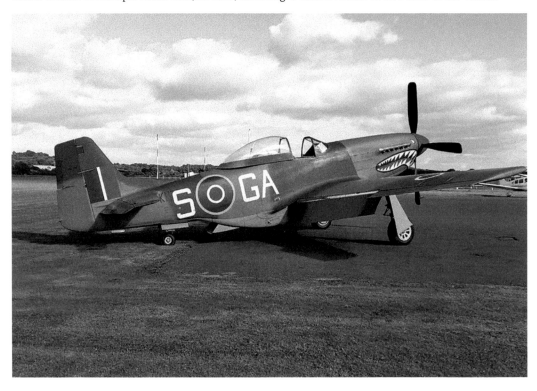

Hixon

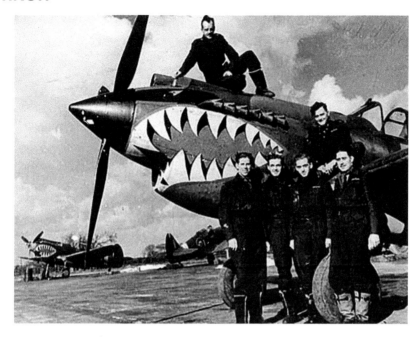

Curtiss Tomahawk at Hixon

Some of the ground crew and pilots of No. 1686 Fighter Affiliation Flight gathered by one of their Curtiss Tomahawks. The flight provided simulated fighter attacks for the Wellington bombers of No. 30 Operational Training Unit. Tomahawks often acquired shark's mouth markings because of the position of the radiator under the pointed nose. A Shark's Mouth returned in 2012, on a Lightning cockpit, for an open day at Air and Ground Aviation's Open Day.

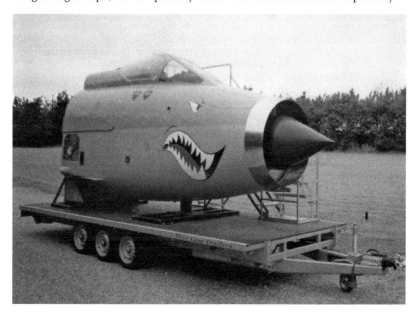

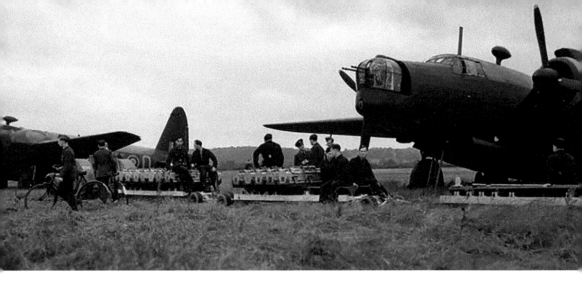

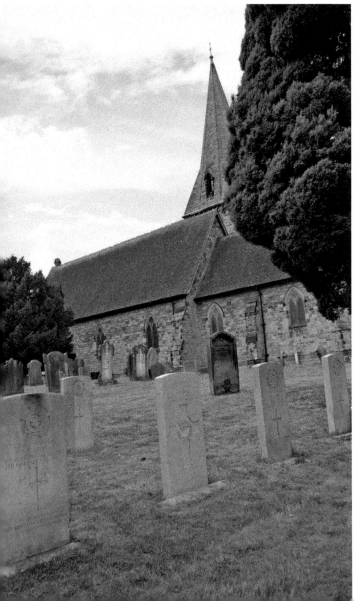

Wellington Bombers of No. 30 OTU

No. 30 Operational Training Unit trained bomber crews on Vickers-Armstrong Wellingtons for the whole of its existence at Hixon. Here, ground crew tend to a row of Wellingtons looking towards Stafford beyond the ridge in the distance. Hixon churchyard testifies that at least five trainee crew members did not return to their native Commonwealth countries.

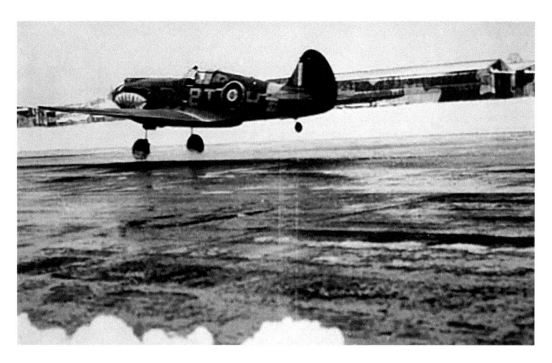

Tomahawk Take-off
A Tomahawk of No. 1686 Flight takes off on a very snowy day. Most OTUs had a Fighter Affiliation Flight, usually equipped with old and tired front-line fighters, which would undertake mock attacks on the new bomber crews to practise their defensive tactics. This Tomahawk is taking off west to east, over the end of Hixon village. Some of the three Hixon runways have been taken up, seen here in piles of hardcore on one of the surviving sections.

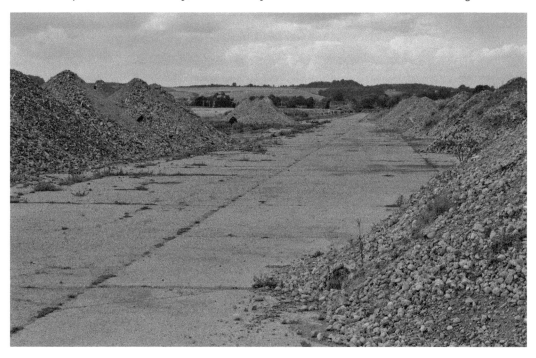

Trainee Bomber Crew

Four members of a trainee bomber crew at Hixon, including the pilot and navigator. At OTUs crews were not assigned to one another but were allowed to coalesce in a large gathering, where the whole of an intake, none of whom knew one another, were told to mix and form themselves into crews, to include a pilot, navigator, flight engineer, wireless-operator/gunner and one or two other gunners. The control tower at Hixon is still in use, but refurbished as the offices of the company which runs the industrial estate that the airfield has become.

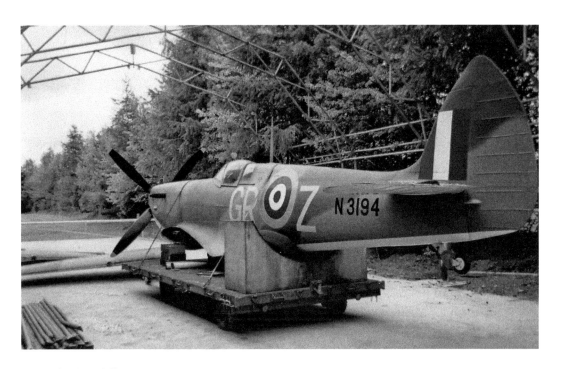

Plastic Spitfire

This is not a wartime picture at all, but a fibreglass Spitfire bought by Air and Ground Aviation, and mounted on a pole outside their offices for a while. It has subsequently been sold. Air and Ground 'part out' aircraft: that is, they reduce them to spare parts and scrap. A number of the T2 hangars at Hixon still survive, many of them re-clad, but this one, now Unit 2, is still original.

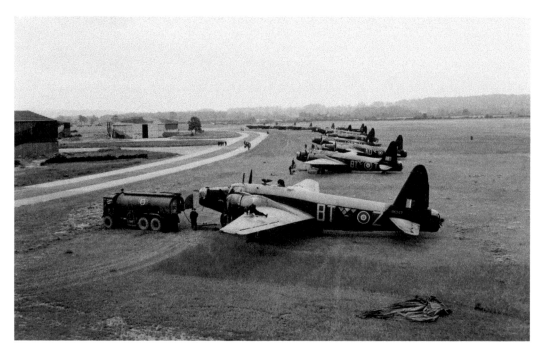

Wellingtons Lined Up at Hixon

This is the most famous photograph taken at RAF Hixon, of a dozen No. 30 OTU Wellingtons lined up. A painting of this scene now hangs in the offices of the Industrial Estate Management Company, which occupies the control tower. The third Wellington in the row has the code 'KO', which means it is an ex-No. 115 Squadron aircraft. The other aircraft have No. 30 OTU's own code. The same area today is now a wheat field, and the airfield buildings are an industrial estate.

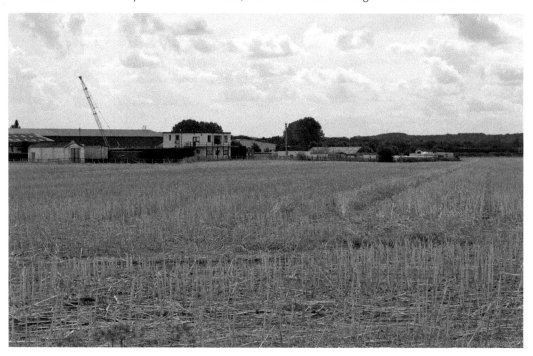

Lichfield

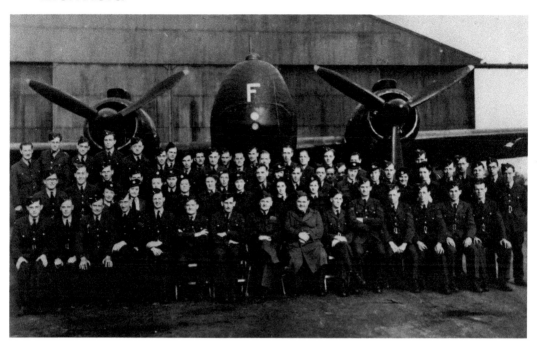

No. 6 Air Navigation School Personnel
Lichfield was the home of No. 27 Operational Training Unit during the war, with Wellington bombers. After the war the Wellingtons returned in the shape of T.10 Navigation Trainers, modified by Boulton Paul Aircraft in Wolverhampton, who replaced the front gun turret with a fairing as seen on *F for Freddie*, standing behind the personnel of No. 6 Air Navigation School who operated them, and the Varsities which replaced them. Most of the hangars at Lichfield still survive, as warehouses, like these three Lamellas.

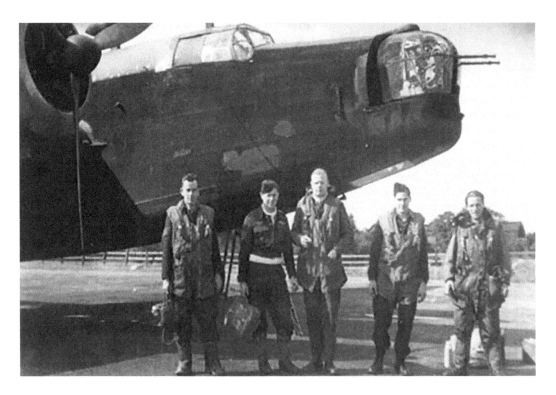

Wellington Bomber Crew

Bomber crews came together at OTUs to put into practice the training they had received in all their specialities, and were then knitted together as a team. This process involved the most advanced crews sometimes going on bombing raids over the closer parts of Europe. The L Type hangars, which were grass covered during the war, were mostly used in the war by No. 51 Maintenance Unit, for the storage and preparation of aircraft.

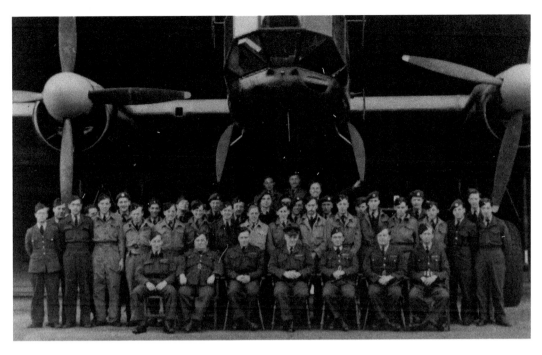

No. 51 MU Personnel and Avro Lincoln

RAF Lichfield remained a storage unit until 1957, when it closed. Here, No. 51 MU personnel pose in front of one of their charges, an Avro Lincoln heavy bomber, outside J4 hangar. One of the No. 51 MU Lamella hangars is now occupied by a recycling company.

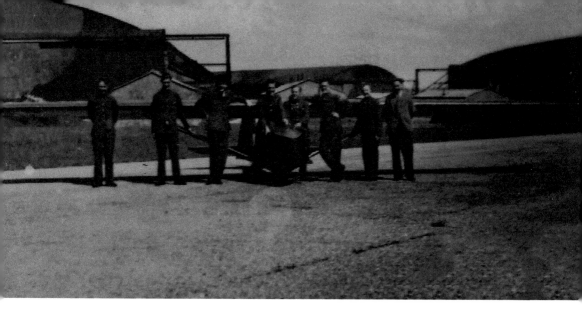

ATC Glider Flying at Fradley

After the war No. 43 Air Training Corps Gliding School moved from Walsall Airport, Aldridge, to RAF Lichfield, and here members of No. 2078 (ATC) Squadron pose with a Slingsby Cadet TX.1 single-seat glider which had formerly been based at Walsall. The hangars in the background are now occupied by Palletways Ltd, who also have this Lamella hangar on the western side of the airfield.

Hutted Accommodation

These are the occupants of No. 234 hut, one of a host of wooden huts which provided accommodation both for the permanent staff of RAF Lichfield and the trainee crews which passed through. Not all trainee crews made it to operations; Fradley churchyard contains thirty-four graves of aircrew killed during the war, most of them from Commonwealth nations. There will have been many more British crews who died and were buried near their homes.

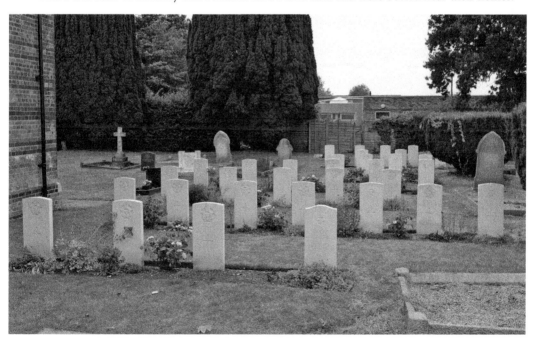

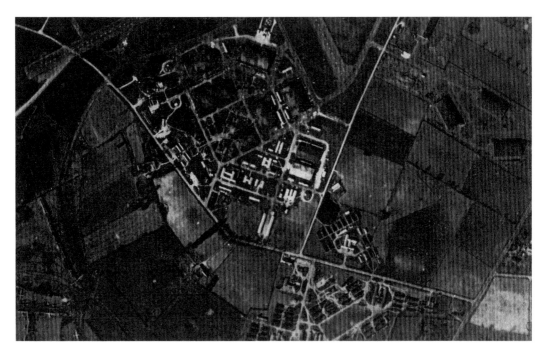

Aerial View of RAF Lichfield

An aerial view of the main hangar complex of RAF Lichfield, taken in March 1949 from 16,500 feet. The main grouping of five hangars are all now occupied by Palletways. Most of the smaller buildings have been cleared away for new industrial units. The lower view shows a small, as yet undeveloped section of airfield.

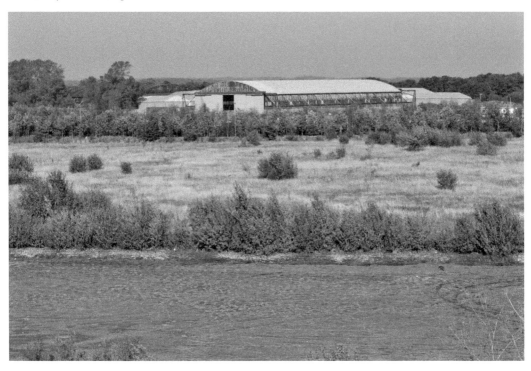

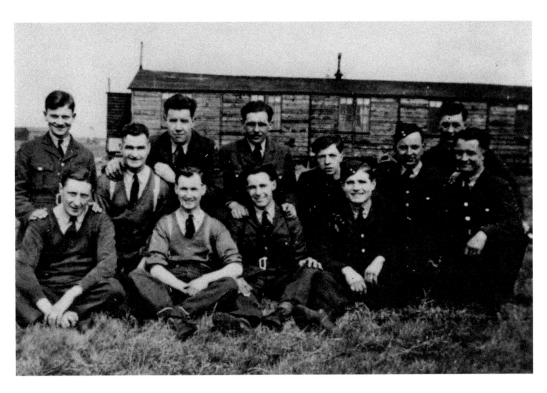

Maintenance Crew
No. 27 OTU fitters outside their billet, one of a host of wooden huts on both sides of Wood End Lane, which are now all replaced by industrial units, like this one of SE Controls.

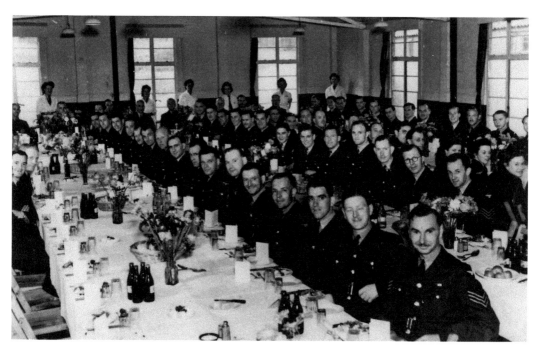

Station Christmas Dinner

OTU staff gathered in a large dining hall for their Christmas dinner in 1944. One of the groups of Lamella hangars over Gorse Lane from the main airfield now has this control tower-like gatehouse.

Pendeford

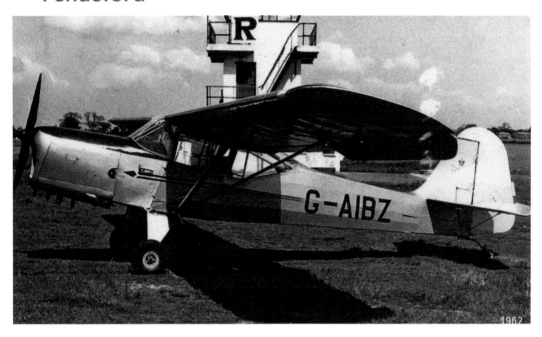

Long-time Pendeford Resident
For a long time, post-war, much of the Aero Club work at Wolverhampton Airport at Pendeford was done by a pair of Auster J1N Alphas, G-AIJZ, and G-AIBZ. The latter is shown here parked by the control tower, which did not have the glass cupola on top until the early 1950s. At around the same spot these days is Creswell Court, a sheltered housing block.

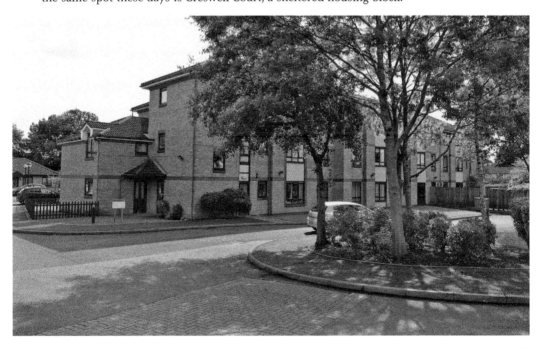

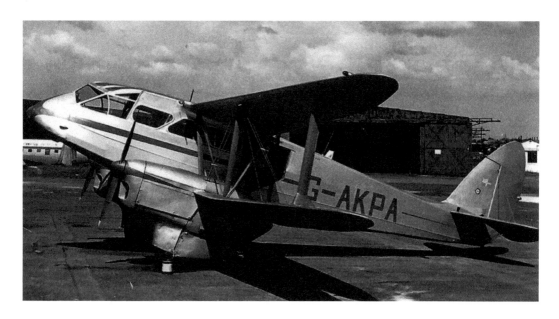

Midland Metal Spinning's Dragon Rapide

The Dragon Rapide biplane was a common sight on the post-war Pendeford, and even operated scheduled services for Don Everall Aviation for a while in the mid-1950s. This one was owned by Midland Metal Spinning, and was based at Pendeford for many years. It stands in front of the maintenance hangar, and the fuselage of a Don Everall DC-3 is visible under the nose. The post-war aerial view shows an aircraft which might be a Rapide in more or less the same spot, one of eighteen aircraft visible. The Shropshire Union Canal is across the top of the photograph.

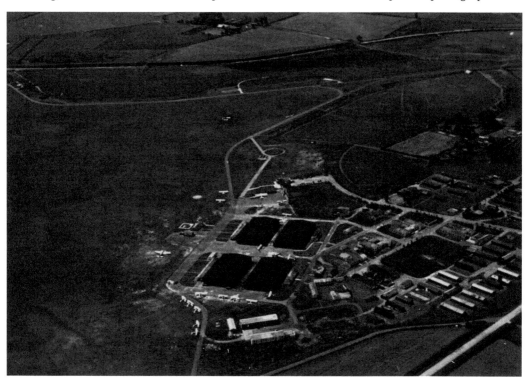

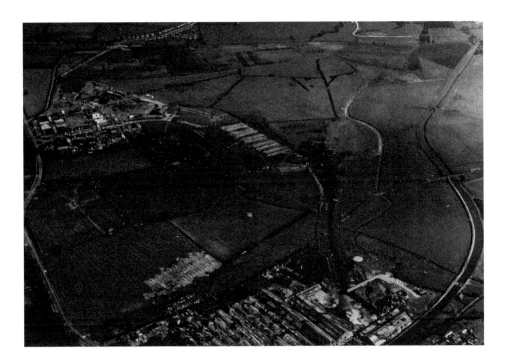

Wartime Aerial View *c.* 1940

This aerial view taken from a Boulton Paul aircraft shows the BPA factory to the bottom, where both the buildings and the concrete apron between the flight sheds have been camouflaged, and the new RAF buildings being erected to the top left. The grass airfield itself has been camouflaged with 'trees' and 'hedgerows' painted on. Five blast pens have been cut into Pendeford Hill, each able to house two aircraft. The Shropshire Union Canal is to the right. The current aerial view shows the surviving part of the Boulton Paul factory, with new factories at the back, where the flight sheds used to be. The airfield in the background is now covered with houses.

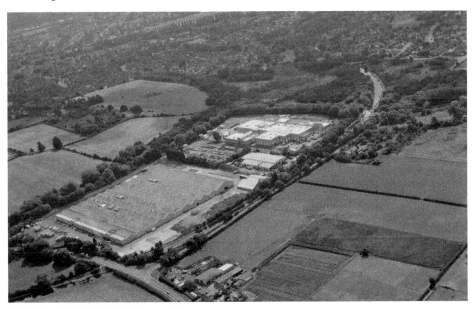

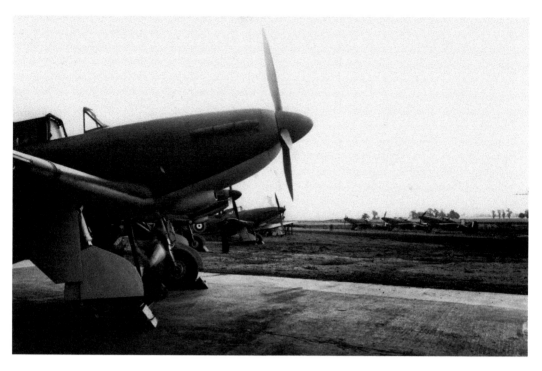

Boulton Paul Defiants Stand Waiting
In the spring of 1940 newly built Defiant fighters are parked either side of the taxiway around to the airfield. Many of these aircraft took part in the fighting over Dunkirk and in the Battle of Britain. Note the fitter working underneath the first aircraft. The area today is occupied by the Cargill chicken factory, part of the Balliol Business Park.

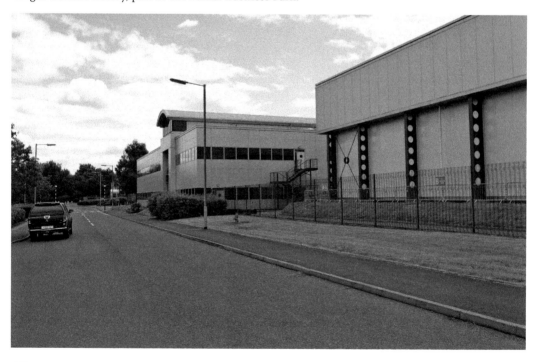

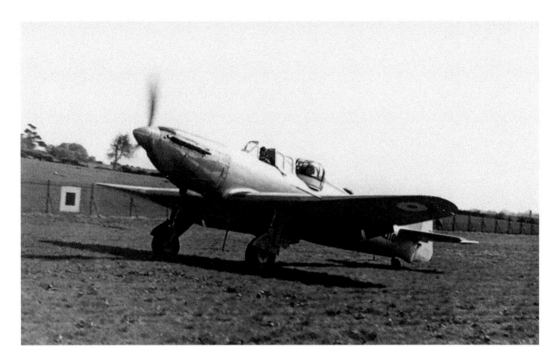

The Defiant Prototype Returns from a Flight

The Defiant prototype was serialled K8310, and flew at first without its lethal gun turret. Here it returns from a test flight with the turret fitted, along the grass taxiway from the airfield to the factory, around Pendeford Hill. This taxiway was later asphalted, because of the heavy use it endured. In the area where every single Defiant taxied out for its first flight there is now a sculpture of three Defiants in relief, in the brick wall next to the Droveway.

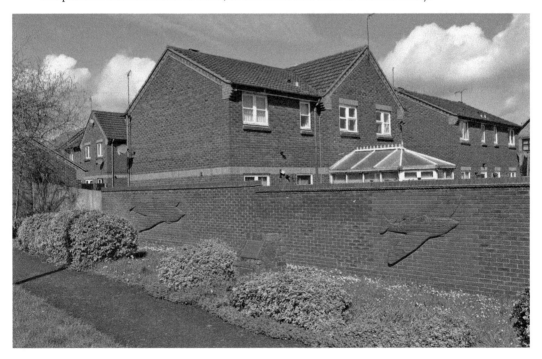

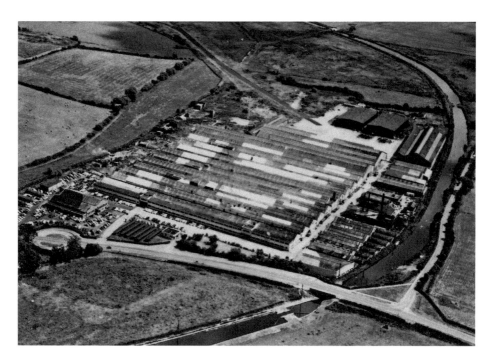

Post-war Boulton Paul Factory

The Boulton Paul factory in the 1950s shows the camouflage wearing off but all the buildings still surviving, including the extra canteen built on the car park to the bottom left – essential to cater for the 5,000 workers who worked there – and the rows of bike sheds by the entrance. Either side of the factory in the canal are the lock gates which were built to prevent the whole contents of the canal flooding the place should the bank be breached by a bomb, the canal being at a higher level. The modern photograph shows that the buildings along the canal have been demolished.

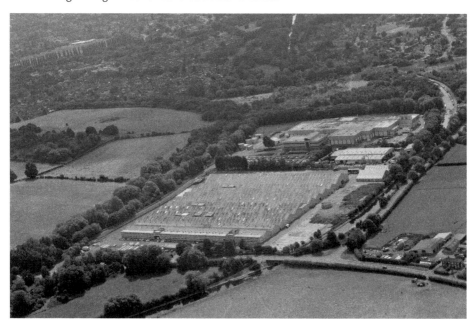

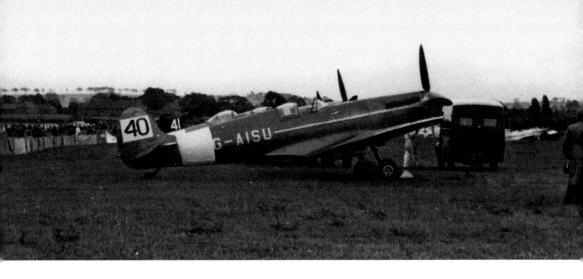

Spitfires in the King's Cup Air Racecourse
In 1950 the famous King's Cup Air Race came to Pendeford for the first and only time, and among the entrants were Spitfires G-AISU and G-AIDN, with No. 41 being Hawker Hurricane G-AMAU. Bushbury Hill is in the background. A Morrisons supermarket now stands where Spitfires flew.

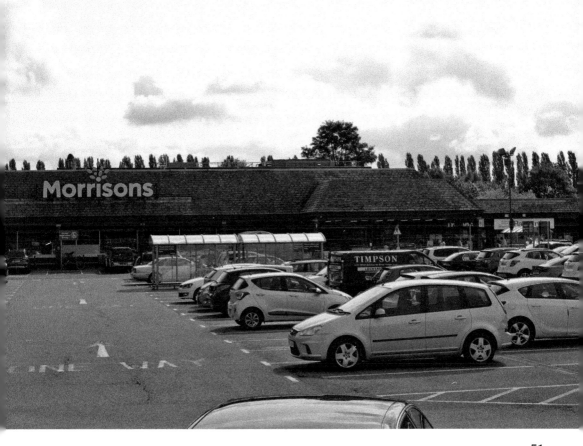

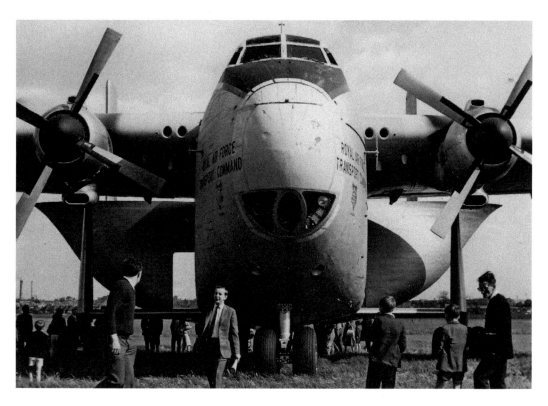

The Largest Aircraft to Land at Pendeford

The 1965 Royal Air Forces Association Air Display saw a huge Blackburn Beverley transport land at Pendeford – the largest aircraft ever to do so. It stands with the rear doors open like elephant's ears, as children stand beneath in awe. To take off it backed right up to the Marsh Lane railings, being able to reverse with reversible pitch propellers, and roared down the runway right through the area where the Pendeford Community Hub now stands.

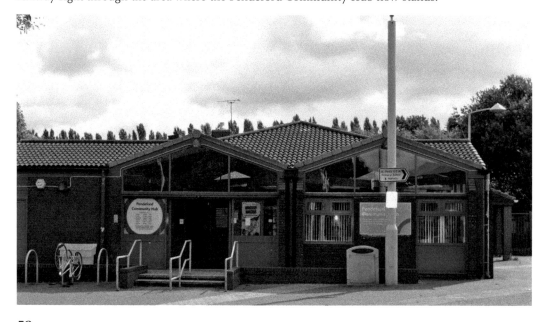

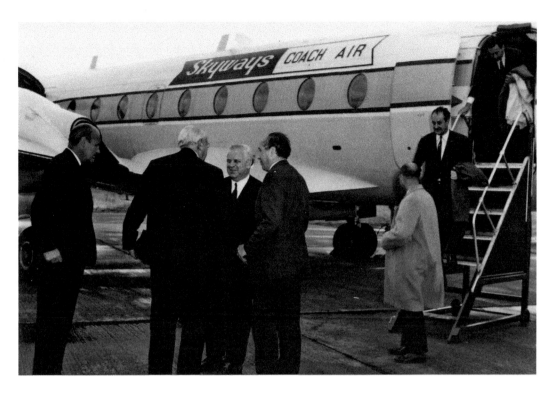

Avro 748 Airliner comes to Pendeford

A twin-engined Avro 748 turboprop airliner brought British and French air ministers to Pendeford in connection with the Concorde project, Dowty Boulton Paul being contracted to make the powered flying control units. Chairman J. D. North, with his back to the camera, shakes hands with the French Minister of Aviation, while the British minister, Roy Jenkins, is to their right. The same area to the rear of the factory shows the demolition of some of the buildings in 2018.

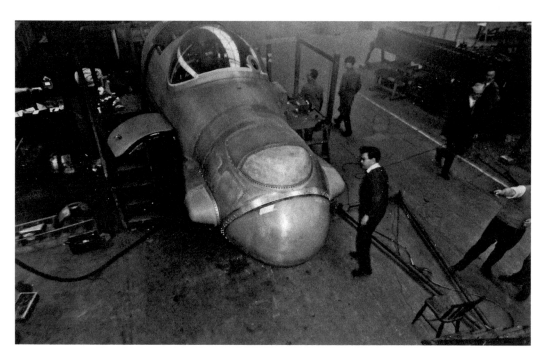

Canberra T.17 Being Produced

For fourteen years various Canberra jet bombers appeared at the Boulton Paul factory for modifications, and here the first of the T.17 Electronic Countermeasures trainers is under conversion, with assorted bumps to house the aerials to jam radar and communications. The same aircraft is now housed not far away in the Tettenhall Transport Heritage Centre.

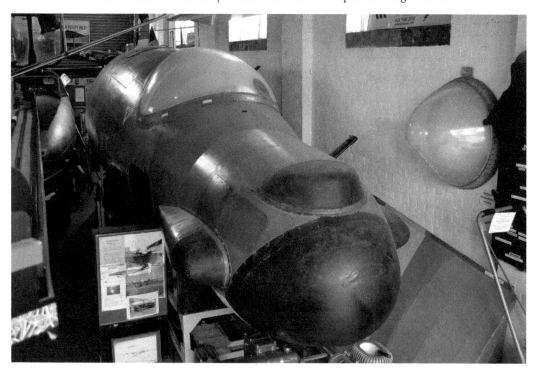

Penkridge

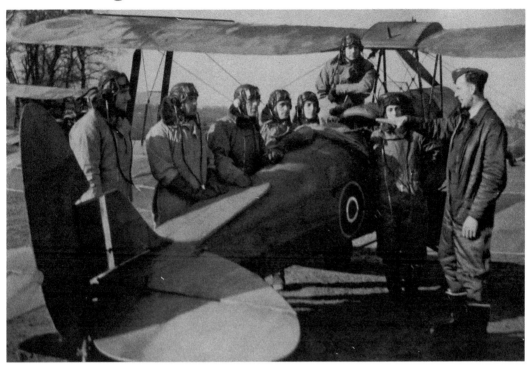

Wartime Tiger Moth Training

During the war up to 105 Tiger Moth trainers were based at RAF Wolverhampton for elementary flight training. To ease the pressure on the runways a Relief Landing Ground at RAF Penkridge was built, where some of the aircraft were based. Here, Turkish students receive instruction from an RAF pilot. Today the central part of RAF Penkridge is a microlight field, renamed Otherton, and here a Tiger Cub biplane microlight in fanciful markings stands outside one of the hangars.

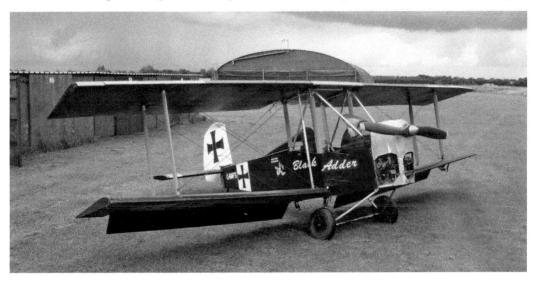

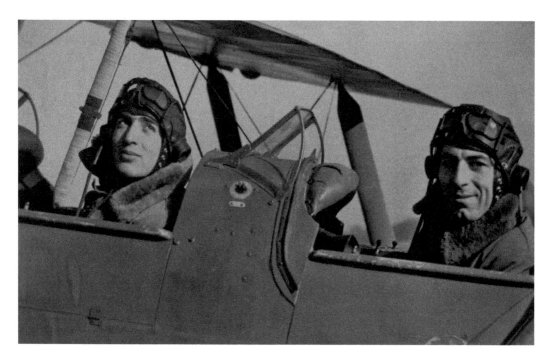

Elementary Training

The Tiger Moths at Penkridge and Wolverhampton were operated by No. 16 Elementary Flying Training School, which was run by a civilian organisation, Air Schools Ltd, using mostly civilian instructor and maintenance staff. Flight training still takes place at Otherton, on both conventional three-axis microlights, and on flex-wing microlights such as this one. Note the M6 motorway in the background.

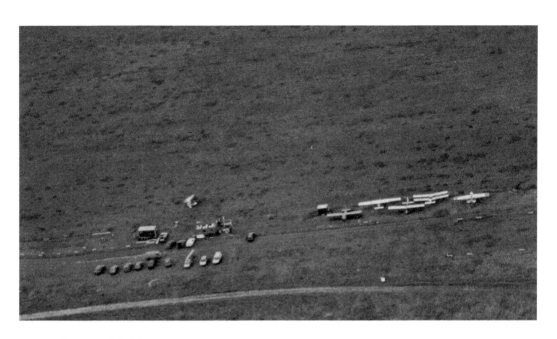

Otherton Airfleld

This aerial photograph shows the early days of Otherton microlight field in 1992, when two portacabins served as the airfield buildings, and six microlights can also be seen. The modern photograph shows the airport buildings having been greatly expanded and the original hangars by the entrance road in the background, there now being many more on the other side of the airfield.

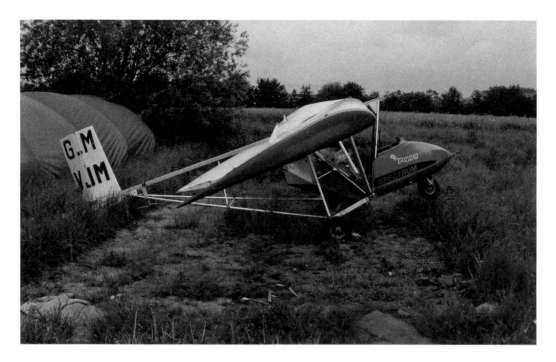

Spectrum Microlight

On the far side of Otherton in 2012, G-MVJM, an engineless two-seat Microflight Spectrum microlight, stands in the area of a row of polytunnels which served as hangars. Built in 1988 it was newly retired, having been based at Otherton all its life. The polytunnels have all now been replaced by permanent hangars and the re-engined Spectrum is preserved inside Wolverhampton's Tettenhall Transport Heritage Centre.

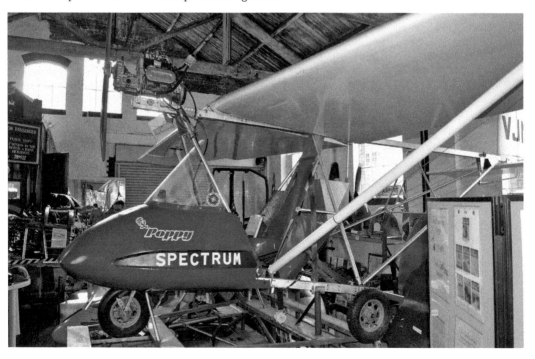

Perton

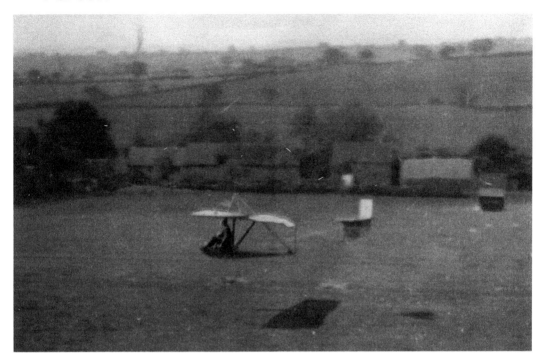

Flying on Glider Bank, Perton
In the 1920s a group of local people formed the Midland Glider Club and bought a Zogling Primary Training Glider to operate from the Perton Ridge, adjacent to the First World War airfield on Fern Fields. The glider was launched from the top of the ridge, taking advantage of the prevailing west winds, using a bungee rope, and was flown down to the fields below, as in this rather blurred photograph. The present section of the ridge is still known as Glider Bank.

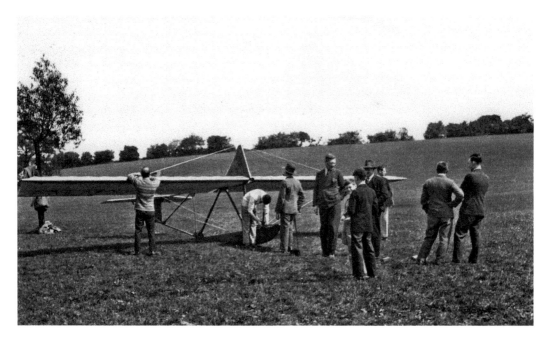

Rigging the Zogling
The Zogling was a basic framework with wings and a tail, and would be dismantled after every session. Later the club bought a more conventional BAC VI glider, which they launched by towing it behind a car on the Fern Fields just beyond the ridge line, where Perton Park Golf Club is now sited.

Aerial Views of the Perton Airfields

The first 1950s aerial shot shows the runways of the Second World War RAF Perton to the upper right, with the houses on Perton Ridge alongside Pattingham Road across the bottom. The First World War airfield on Fern Fields is above these, to the left. Glider Bank was further to the west (i.e. left). The modern photograph shows Pattingham Road in the foreground, with the Perton Park Golf Course above, and the houses of the Perton Estate, built on RAF Perton, in the background.

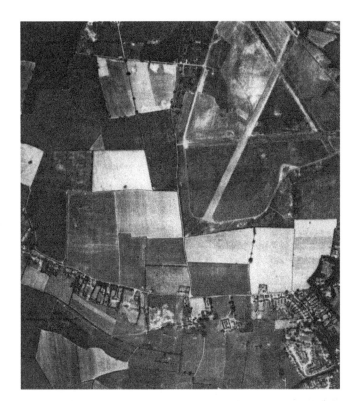

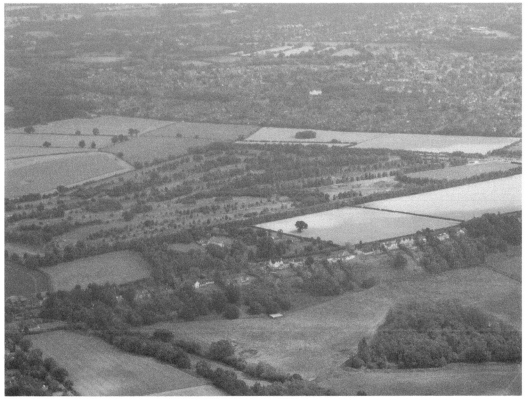

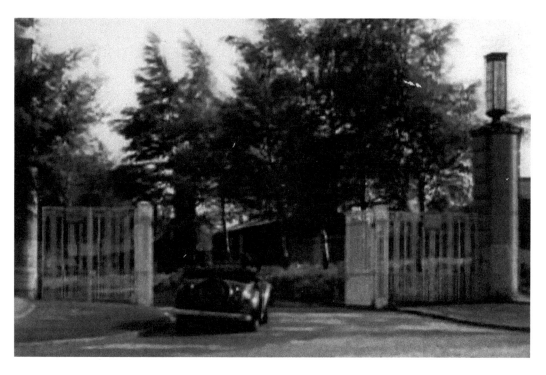

The Entrance to RAF Perton

A slightly blurred photograph of a car turning into RAF Perton at the main entrance on the Newport Road. This also served as the main entrance to the Dutch Camp, the home of the Princess Irene Brigade of the Dutch Army, which occupied much of the site during the war. The junction is now much wider and controlled by traffic lights.

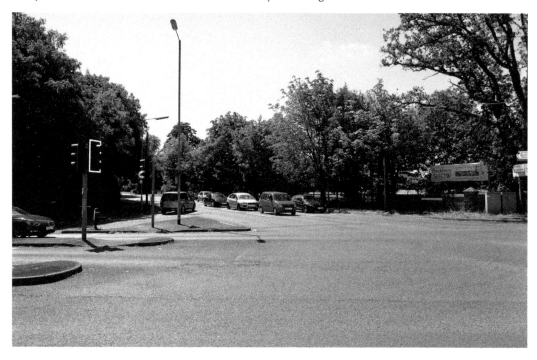

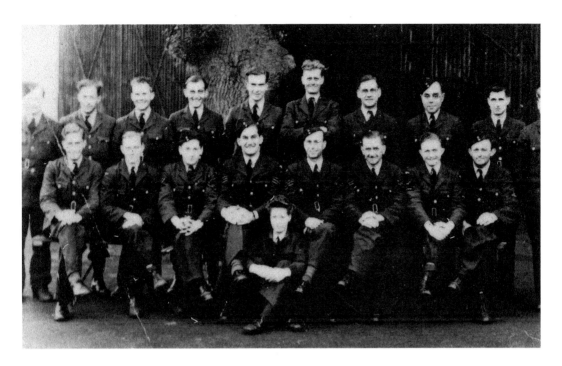

RAF Perton Maintenance Staff

Built as a fighter station, RAF Perton was only used as a Relief Landing Ground for the training aircraft from Tern Hill, Shawbury, and Wheaton Aston. Basic maintenance staff are shown here in 1943 outside the solitary Bellman hangar, not far from the control tower, both of which were in the area of the woods along Wrottesley Park Road. Almost the only sign that there was ever an airfield here is the memorial just behind the Sainsbury's supermarket.

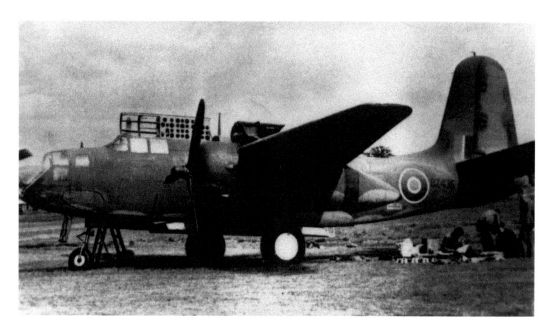

Douglas Boston Bomber on RAF Perton

Boulton Paul Aircraft undertook modifications to the American Douglas Bostons used by the RAF, but flew them from Perton, with its hard runways, rather than the shorter grass runways at Pendeford. Here, equipment is being installed in the wireless bay between the pilot and rear gunner. One of the few surviving buildings lies beyond Wrottesley Park Road on the entrance to Cranmoor Farm. It was designed to train bomb aimers and navigators who lay in a cradle above a map of German targets, but was more usually used as a store.

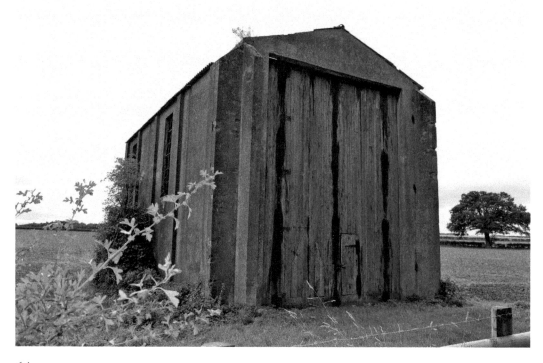

Dutch Soldiers Making Themselves at Home

The Dutch Army took over most of the RAF Perton buildings and built many more to house the 1,500 Dutch soldiers of the Princess Irene Brigade, referring to the camp as Wrottesley Park. Here, some of them help build their camp. There were a cluster of buildings, including a dance hall, around Cranmoor Park Farm, and these have now mostly been converted to housing. This ablution block survives, but not for much longer as it is due to be converted into three houses.

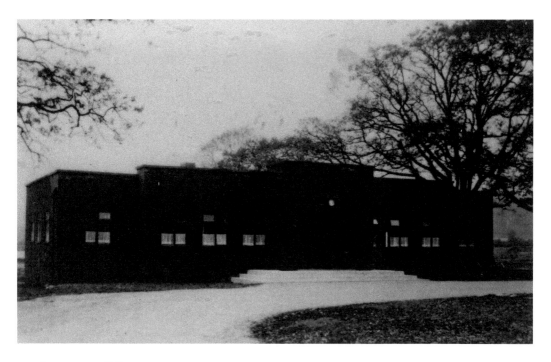

Headquarters Building

At the main entrance by the Newport Road this building was constructed as the RAF gatehouse, but was then taken over as the headquarters building for the Princess Irene brigade. After the war it became a private dwelling, and has now been much enlarged and become a care home.

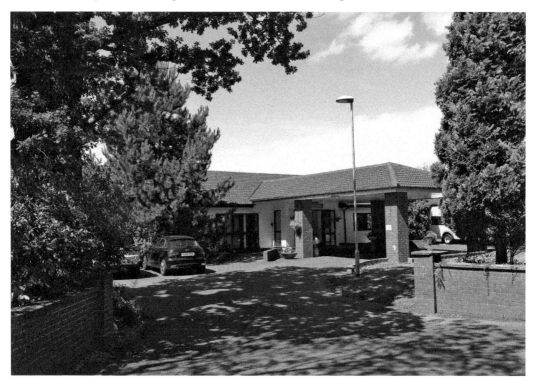

Seighford

Trainee Bomber Crew

RAF Seighford opened as a Relief Landing Ground for No. 30 Operational Training Unit at RAF Hixon on the other side of Stafford. Above, a trainee bomber crew pose in front of a Wellington bomber at Seighford. Wellingtons provided the equipment to mould new crews into fighting units. Flying still takes place at Seighford, and here (below) members of the Staffordshire Gliding Club wheel a vintage Schleicher K8B sailplane, built in 1963, towards the hangar.

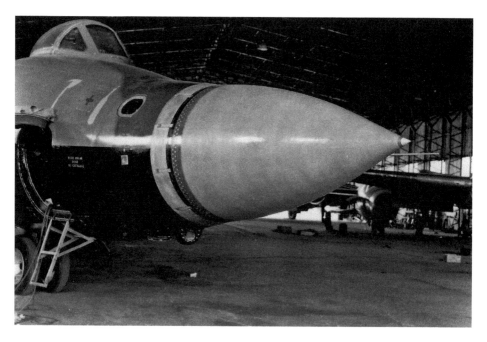

Canberras Fill a Hangar

When Boulton Paul Aircraft took over Seighford for Canberra work, jet bombers filled the three hangars for nearly ten years.

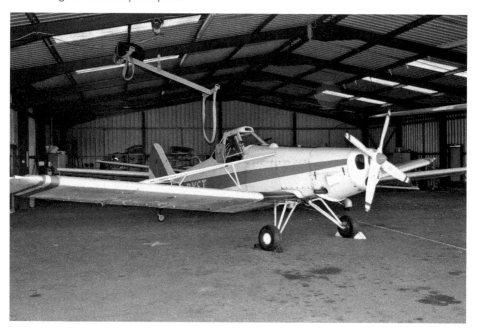

Pawnee Glider Tug

The Glider Club uses this Piper PA-25 Pawnee as a glider tug. Built as a crop-duster in 1965, this Pawnee makes an excellent glider tug, but draws noise complaints from neighbours, who had more to complain about from 1956 to 1965 when Boulton Paul used the airfield as their Flight Test Centre.

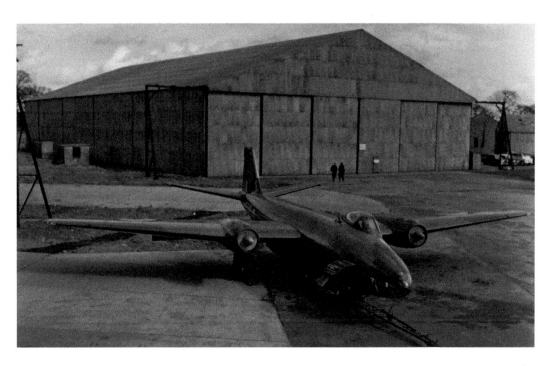

Canberras come to Seighford

When Boulton Paul Aircraft began receiving contracts for Canberra bomber modifications they refurbished the derelict Seighford Airfield as their Flight Test Centre and added a third hangar on the other side of the Woodseaves Road. Above, B.8 WT329 awaits towing across the road on to the airfield. That side of the road is now an industrial estate, much of it occupied by Stan Robinson Transport, seen below.

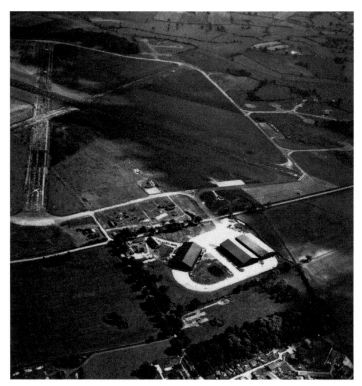

Aerial View of Seighford

An aerial view of Seighford in the 1960s shows the three hangars on one side of the Woodseaves Road, the one on the left having been built by Boulton Paul, and the taxiway across the road turning right to a new hardstanding, and to the left to the small complex of buildings by the control tower. BPA only used the main runway which they resurfaced. Currently the small group of buildings by the partially demolished control tower lies derelict.

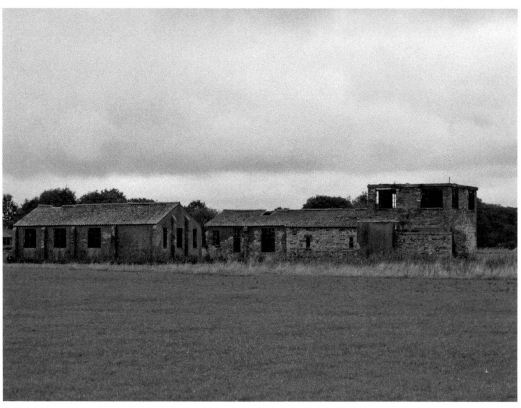

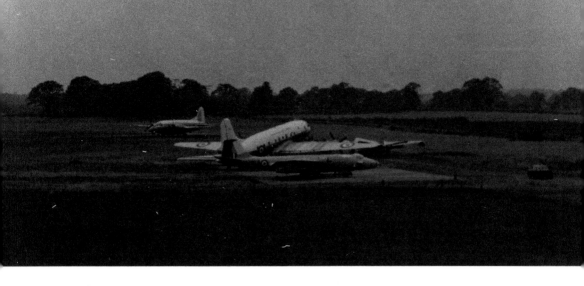

Crowded Scene in the 1960s

The new hardstanding on the airfield side was sometimes too small, and here are two Canberras and a visiting RAF Handley Page Hastings transport, with a Vickers Varsity on the runway beyond. Looking in the other direction the hardstanding can be seen to be unused, with the derelict control tower in the background and the glider field beyond the fence with the windsock.

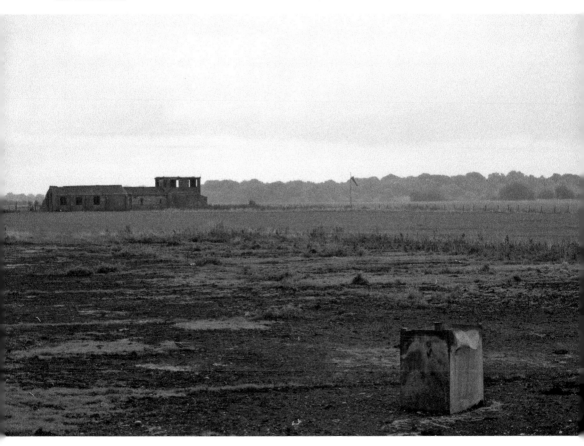

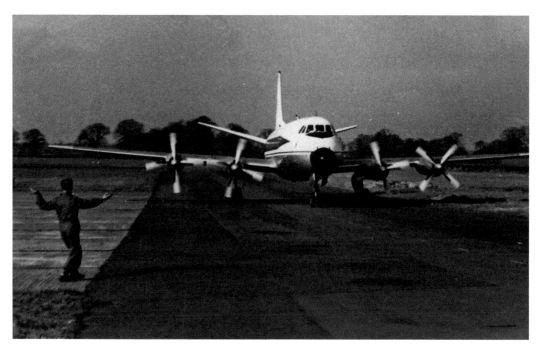

Turboprop Airliner Arrives at Seighford
A Vickers Viscount airliner of the Empire Test Pilots School makes a visit to Seighford, full of trainee test pilots. A Boulton Paul employee directs it from the taxiway onto the hardstanding. The background to the upper photographs is now filled with lines of glider trailers housing the many private gliders based at Seighford.

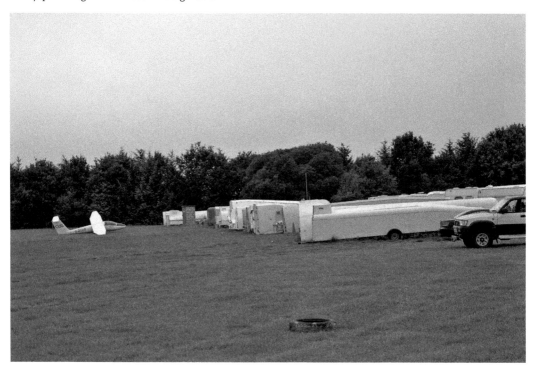

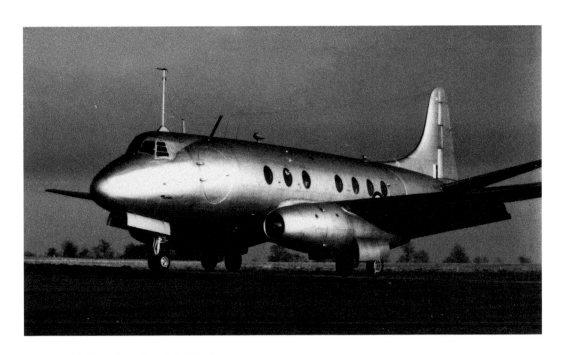

Jet Airliner Based at Seighford

For a long while Boulton Paul used the Tay-Viscount to test Powered Flying Controls with electric signalling (fly-by-wire) and it became the first aircraft in the world with fly-by-wire on all three axes. It ended its life at Seighford after a fire in the wing. Fly-by-wire at Seighford today means winch launching, and here gliders are gathered at the Seighford end of the runway on an inclement day waiting for the cable to be returned for the next launch.

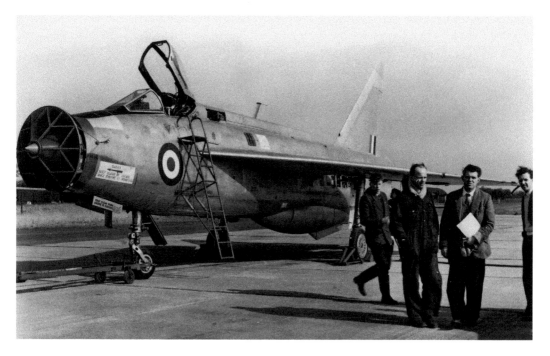

Lightnings at Seighford

Following the Canberras, Boulton Paul undertook modification work on English Electric Lightnings at Seighford. In particular a new larger belly tank was tested on the Lightning prototype, and ten F.1 Lightnings, like XG310 shown here, were each partially modified to F.3 standard. Yards from the upper photograph the gliding club hangar is packed with aircraft, some suspended from the roof on winches.

Stafford

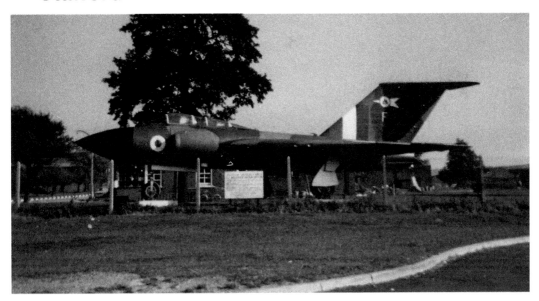

Javelin Gate Guardian at RAF Stafford
Guarding the gate of the RAF storage base of RAF Stafford in the 1960s was this Gloster Javelin FAW.2, XA801, late of No. 46 Squadron. It was scrapped in 1993 and replaced by a Harrier, XZ987, which, because of local support, survived a plan to remove it when the base became MOD Stafford.

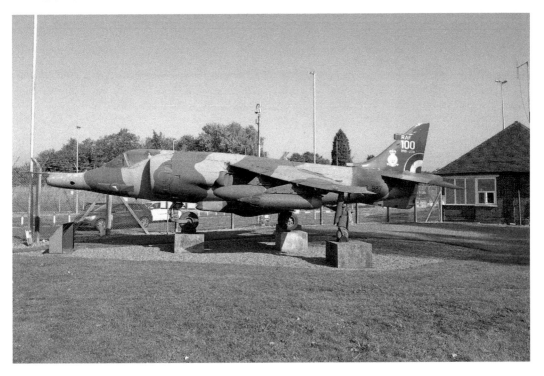

RAF Stafford Takes Shape

In 1938 a huge storage base east of Stafford was taking shape. This was No. 4 site, built in the fields. Now much reduced in size and renamed MOD Stafford, it currently houses army units as well as retaining its storage function. There was never an airfield at Stafford, but these days it has a thriving helipad where passing RAF and army helicopters often stop to refuel, like this Puma.

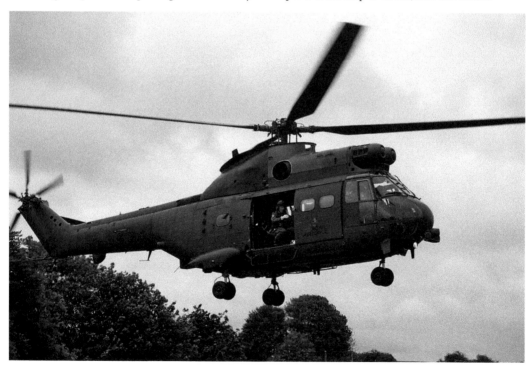

Stoke

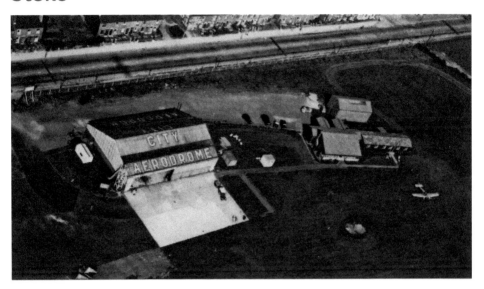

Stoke Airport as Built

Stoke built their municipal airport next to the Uttoxeter Road at Meir. This was just a grass airfield with a single small hangar and a clubhouse for the North Staffordshire Flying Club, though Railway Air Services operated a request stop for their scheduled flights, the stationmaster at Meir station radioing aircraft to land if there were passengers, and travelling the short distance to supervise them. Later Staffordshire Potteries built a huge complex near the entrance, incorporating into it the original hangar seen near the top left-hand corner.

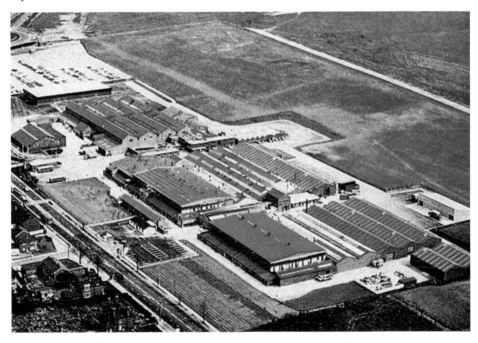

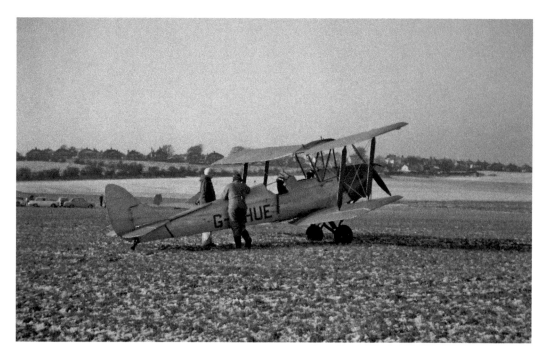

Tiger Moth on a Winter's Day

After the war the airfield at Meir was mostly used by ATC and Staffordshire Gliding Club gliders, and this Tiger Moth, G-AHUE, was in occasional use as a glider tug. It is seen in the winter of 1969/70 and the pilot is Ken Sherriff, who lost his life the following year when his tug collided with a glider. Near the spot today the Potters Bar public house is sited in the centre of the housing estate which occupies the airfield.

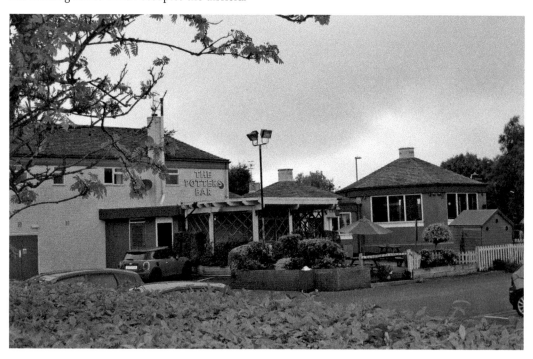

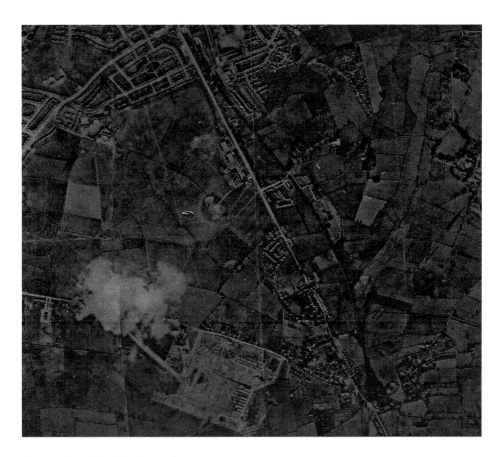

German bombing Photograph

An aerial photograph taken by the Luftwaffe in July 1941. The Rootes Bros shadow aircraft factory, where Blenheims and Beaufighters were built, is at the bottom, while the hangar complex is by the road to the right. The airfield has been disguised with painted 'hedgerows'. In the centre of this image today would be the small shopping centre of the housing estate.

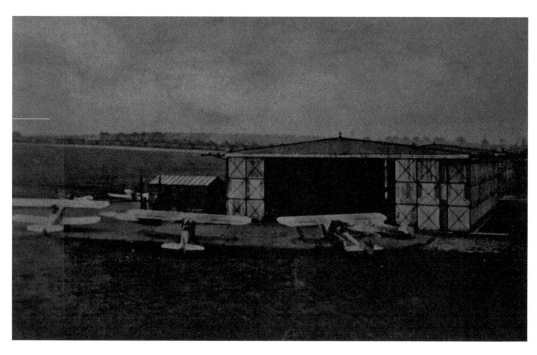

New RAF Hangars

During the war the RAF used Meir for No. 5 Elementary Flying Training School, but these two Bellman hangars were erected before the war for No. 28 Elementary and Reserve Flying Training School and for No. 1 Flying Practice School. The site is now occupied by a B&Q warehouse.

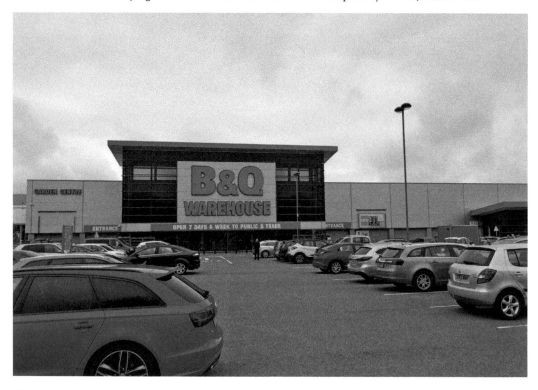

Tatenhill

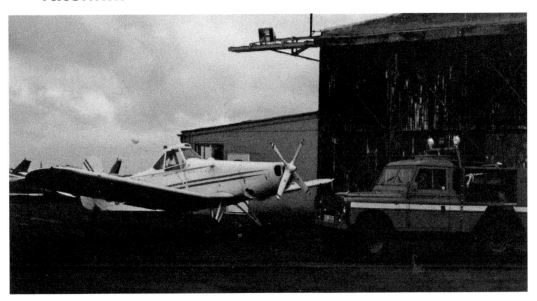

East Staffordshire's Airfield

Tatenhill was built in 1941 and served as a satellite of various training units during the war, first Lichfield, then Wheaton Aston and then Tern Hill. It fell to Bass's Brewery to reopen it after the war as a home for their corporate aircraft. They built half a Bellman hangar, shown here, with a control tower in the corner, and Tatenhill became a home for local light aircraft like this Piper Pawnee, seen parked by the airfield Land Rover fire engine, and the more recent Bellanca Decathlon viewed from the opposite direction.

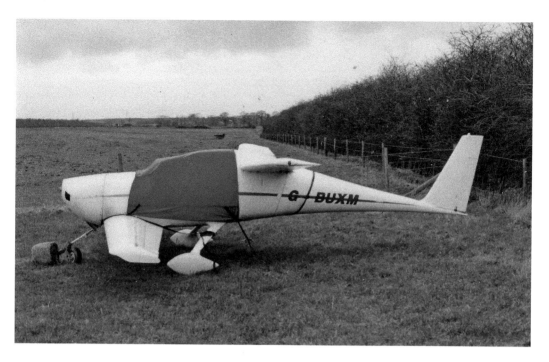

An Unusual Home-built

A home-built Rutan Quickie – a very unusual fibreglass tandem-wing design – seen parked engineless at Tatenhill in the early 1980s. Around the same spot today the Midlands Air Ambulance, now based in its own hangar at Tatenhill, awaits a call-out.

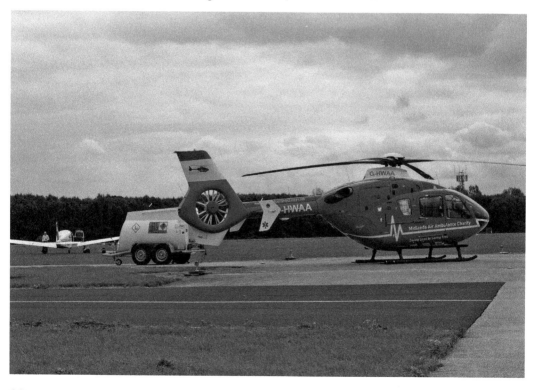

Ghosts of Forgotten Wings

Light aircraft parked near the end of the runway in the early 1980s. A number of wartime buildings were scattered around the airfield for many years. Slowly deteriorating – after all they were not designed for a long life, just wartime service – they have recently been refurbished and become the home of local companies like JWF.

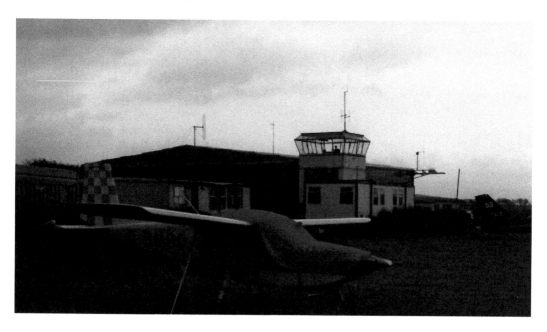

Outside Aircraft Parking

An ARV1 Super, G-BMDO, parked near the hangar on an inclement day. This aircraft has since been reregistered G-YARV. Today the aircraft of the resident Tatenhill Aviation display a series of personalised registrations.

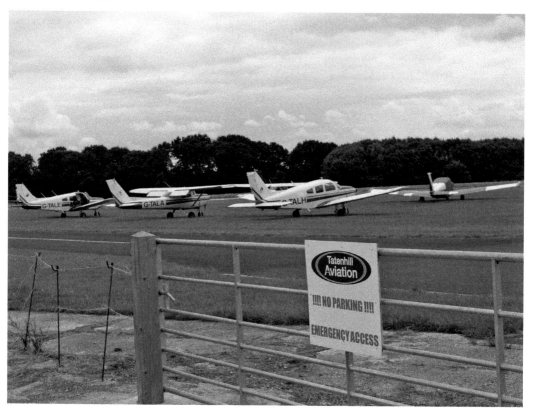

Walsall

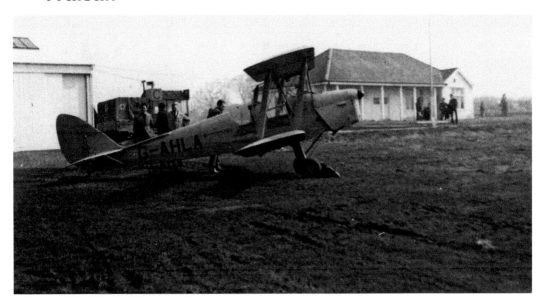

A Tiger Moth Awaits Flight
Walsall Aerodrome at Aldridge was opened for business in 1933, with a solitary hangar and the Walsall Aero Club clubhouse seen here in the background. Post-war civil flying returned and in 1947 a Tiger Moth stands waiting, engine running. Looking today in the opposite direction, the clubhouse has gone but the grass airfield still remains.

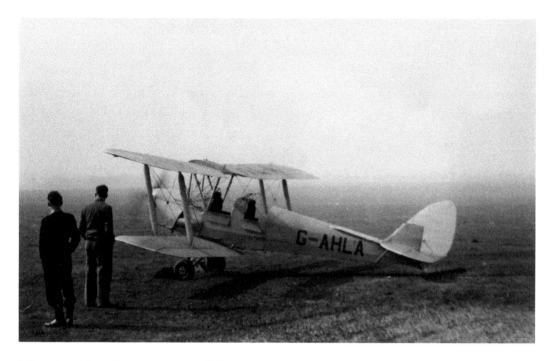

Misty Conditions Seem to Prevent Flight

The photograph taken from the opposite direction of Tiger Moth G-AHLA shows very misty conditions, which may be the reason take-off has been delayed. The other side of the grass strip cannot be seen. In the same area as above, this obstacle course (below) now dominates the upper part of the airfield.

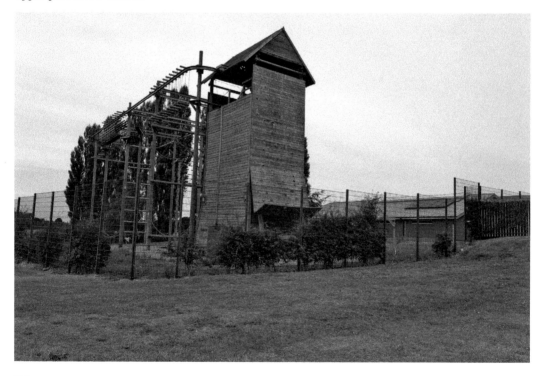

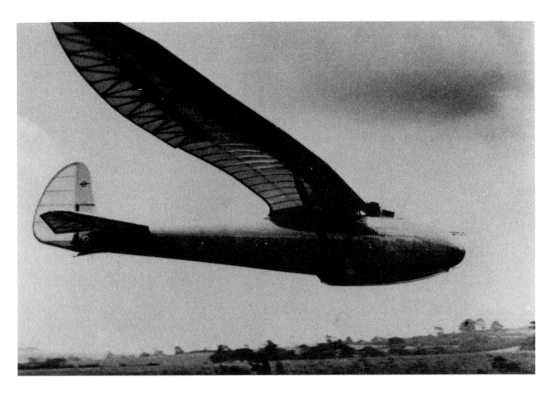

Amy Johnson Flies at Walsall

On 2 July 1938, the famous aviatrix Amy Johnson flew her Kirby Kite glider. She made three flights but on the third the glider turned over. Fortunately, she was not hurt. The poplar trees by the outdoor adventure facility would provide a severe obstacle to her flying these days.

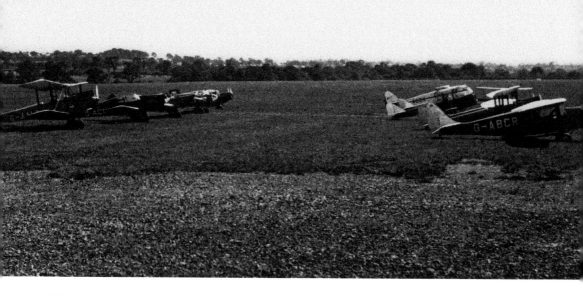

Visiting Aircraft

A collection of mostly visiting aircraft lined up below the clubhouse on the official opening day, 6 July 1935, including two Gipsy Moths, a Miles Falcon, Monospar, de Havilland Dragon and a Puss Moth. The airfield looks the same today; even the grass has been cut in 'runways' to preserve wildlife areas. Only the dog walkers stand in the way of flying.

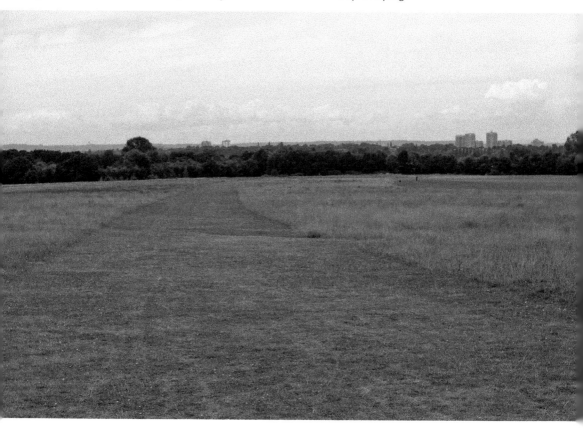

Westland Widgeon Aircraft

The small club hangar at the top of the airfield housed the Westland Widgeon of the Aero Club's President, Ivor Tidman. During the war the airfield was used by the gliders of No. 43 Air Training Corps Gliding School, and by the aircraft being serviced by Helliwells, who built a factory pre-war on the western edge. Aerial adventure today involves only the obstacle course, seen below.

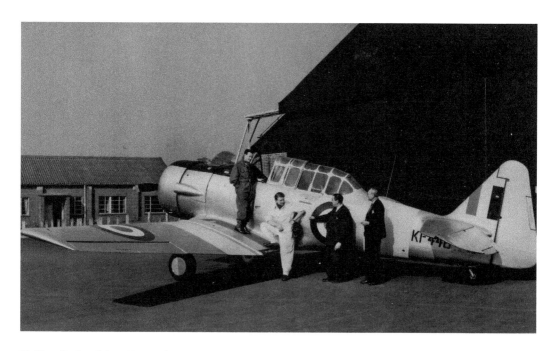

Helliwells Servicing Harvards

Above: Post-war Helliwells received contracts to service and overhaul Seafires and Harvard trainers, including this one by their main hangar. The Helliwells factory has now gone and has been replaced by a small industrial estate.

Below: Still surviving in the woods to the top of the airfield is 'The Top Hangar', which had also been used by Helliwells. More recently is was utilised for storage by Walsall Council, though it is currently empty.

Wheaton Aston

Airspeed Oxford Familiar to Wheaton Aston

Above: Wheaton Aston, known to locals as Little Onn, after a nearer but smaller village. It was built in 1941 as a satellite for No. 30 OTU at RAF Hixon, with three substantial runways, but in practice was used by the Airspeed Oxfords of No. 11 SFTS from Shawbury and No. 21 (P) AFU, who were based there. It became one of the busiest airfields in the country, its Oxfords basically being used for pilots trained abroad to acclimatise to British conditions. The derelict, forlorn control tower is a bleak reminder of long-gone days.

Below: Oxfords were a very common sight and this was the last to be seen, being Boulton Paul's own corporate aircraft. It would have flown over Wheaton Aston en route from Pendeford to Seighford.

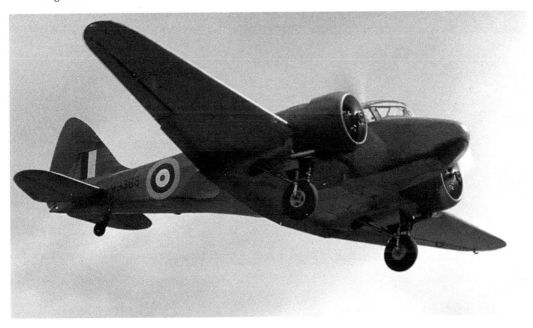

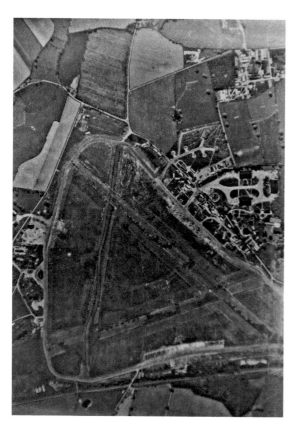

Post-war Aerial View

Left: The three-runway layout is plain in this aerial view, with the Shropshire Union Canal running along the bottom, the main hangar complex at the other side of the Little Onn Road, and forty-six aircraft parked all over.

Below: The runways largely remain, but now house a pig-producing company, with piles of rubble and stacks of straw bales.

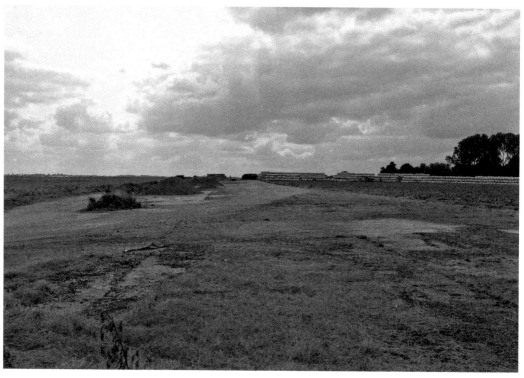

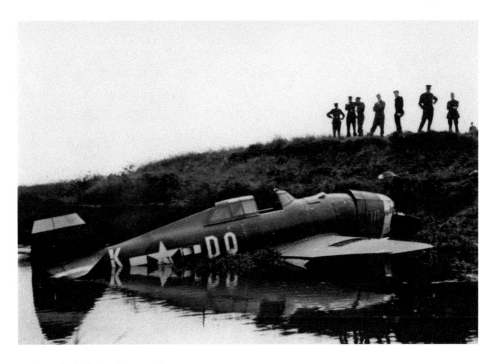

A Thunderbolt in the Canal

Above: This Republic P.47 Thunderbolt from the training base at Atcham in Shropshire suffered engine trouble and tried to land at Wheaton Aston. Sadly it fell short of the main south–north runway and landed in the Shropshire Union Canal. RAF personnel consider the problem.

Below: Near the same spot a narrowboat chugs quietly by – a startling contrast to what in 1945 was a very noisy place to be.

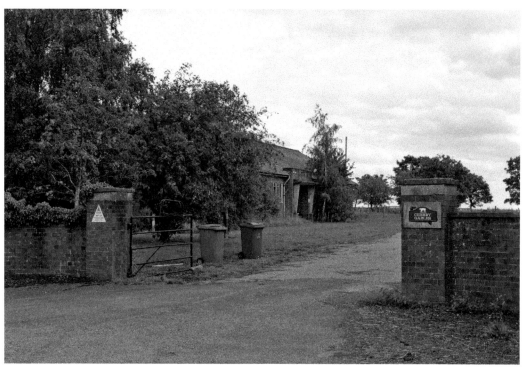

The Skeleton of an Airfield
The old main entrance now features the wheelie bins from the resident farm and the runways still scar the landscape.

Acknowledgements

Over many years a great number of people have given me photographs of various Staffordshire airfields and I fear I am unable to recall in many cases who gave me what. I beg forgiveness from those who I fail to mention, along with those I can recall, including: Vaughan K. Meers, Maurice Marsh, Dave Welch, Mike Ruttle, the RAF Lichfield Association, the *Burton Daily Mail*, Grp Capt Edwin Shipley, Barry Abraham, Jim Boulton, Peter Brew, Eric Holden, Jack Chambers, Dowty Boulton Paul Ltd, Eric Ralphs, Keith Rogers and Chris Martin. I would also like to thank Tim Brannon of Air Midwest for flying me for some of the modern aerial photographs.

Also available from Amberley Publishing

ALEC BREW

BOULTON PAUL
DEFIANT

AN ILLUSTRATED HISTORY

Available from all good bookshops or to order direct
Please call **01453–847–800**
www.amberley-books.com